Nr. 130. Achillea millefolium

PAPER POETRY

HELENE AND SIMONE BENDIX

-

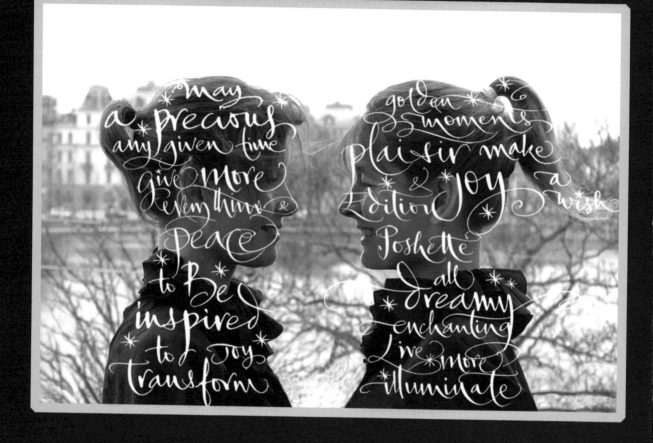

PAPER POETRY
HELENE AND SIMONE BENDIX

–

PHOTOGRAPHY BY BEN NASON

KYLE BOOKS

First published in Great Britain in 2018
by Kyle Cathie Limited
Part of Octopus Publishing Group Limited
Carmelite House, 50 Victoria Embankment
London EC4Y 0DZ
www.kylebooks.co.uk

10 9 8 7 6 5 4 3 2 1

ISBN 978 0 85783 490 4

Text © 2018 Helene and Simone Bendix
Design © 2018 Kyle Books
*Photographs © 2018 Ben Nason**
**except pages: 12–13, 71, 97, 140–142 © Kasper Winding*
11, portrait of Hans Christian Andersen, Wikimedia
7 © Asger Mortensen
104, 108–109 © Ilaria Costanzo
2, 6, 8 © Vibeke Winding
40 © Anna Ambrosi
18, 19, 41, 46, 51–52, 64–70, 76–79, 94–96, 98, 102, 113, 124, 121, 131–133, 137 © Simone Bendix

Project Editor: Tara O'Sullivan
Editorial Assistant: Sarah Kyle
Papercut design: Helene and Simone Bendix
Book Design: Claudia Astarita (Icons by Claudia Astarita and Dinosoft Labs-A.Gazzellini-M.Jasinski-B.Novalyi from the Noun Project)
Illustrations: Helene Bendix
Photographer: Ben Nason
Production: Lisa Pinnell

A Cataloguing in Publication record for this title is available from the British Library.

Printed in China

CONTENTS

"

There are few friends of Simone and Helene who do not have some marvellous little something cut out of paper by them: a stemmed camellia with crumply, layered petals of polka-dot tissue paper; an artful phalanx of feathers scissored out of French road maps; a wreath of leaves cut out of toothpaste boxes, leftover gift wrap, or a deck of cards that's missing one or two. Helene and Simone have made many sturdier things for all of us, like olive oil and patchwork cushions, but strangely enough, it is the paper cut-outs, so seemingly fragile and fleeting, that last forever.

TO CUT IS TO BE

✂

As the world turns digital, there is a poignancy to paper that the LED screen can never convey. What are pixels to the glorious 3D profusion of paper butterflies under a bell jar, each one rapidly and expertly snipped out of paper? For the twins wield scissors with outlandish speed and dexterity, producing doves and sparrows out of a single sheet like a magician ushering them out of his top hat. Or, rather, they are the magicians, clipping and cutting through A4s till nothing is left but the filigree of a tree, a vine or a catchy phrase in calligraphy. Only their wit is as sharp as their shears.

'Because it's cheap and you have everything you need right here!', says Simone, when I ask why it is paper she and Helene prefer to make things out of over wool or leather or horse-chestnuts (though, to be fair, they make things out of those as well). 'You don't need to go out and buy anything. Paper is all around us, and so much of it is wasted, just thrown away when you've brought home whatever it is you just bought in nicely-patterned packaging.'

Rarely does thrift form such cosy union with poetry. But their unlikely alliance makes Helene and Simone's handiwork many cuts above the decorative. Besides our homes and the odd shop or exhibition space, the sisters have festooned a hotel room in Florence with paper arabesques. And they have enlivened immeasurably a seaside retreat for autistic schoolchildren, deploying durables like paint, reupholstery and curtains amongst the dazzling ephemera of book sculptures and cut-outs. None of it is expensive stuff, but all of it has been done by hand. And it is the great care that goes into them – the infinitely patient and meditative cutting and folding, over and over again – that seems to rise up out of the paper into the air, cheering the soul. There is an essential democracy to the paper worlds Simone and Helene make. Beautiful and achievable, they are a call, not to arms, but to our scissors, for *esse est secare*: to cut is to be.

"

CLARA YOUNG

→*Helene (left) and Simone (right) wearing their own Edition Poshette designs – necklaces, bags and belts.*

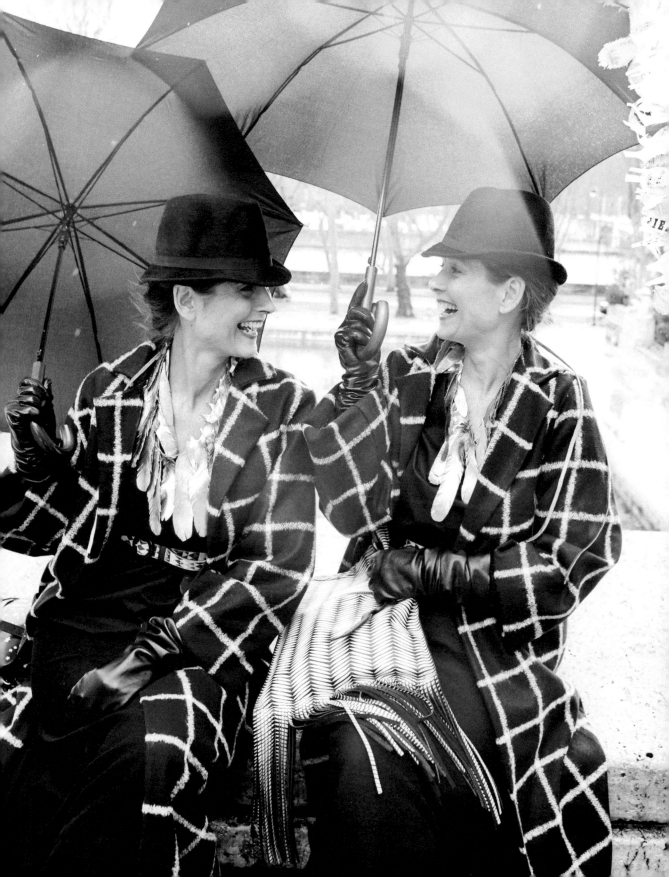

We grew up in Denmark, where many seasonal traditions involve papercutting, and we were definitely drawn to the symmetry and the magic we could create with just a piece of paper and some scissors.

There is something quite magical about papercutting. It allows for imperfections – in fact, they often make the piece more beautiful. This is something we would like to encourage in everyone that experiments with papercutting – the freedom and courage to reconnect with a childlike sense of the whimsical and wondrous.

IN ALL HONESTY, NEITHER OF US CAN REMEMBER EXACTLY WHERE OUR LOVE OF CREATING WITH PAPER CAME FROM. MAYBE WE WERE BORN WITH A PAIR OF SCISSORS IN OUR HANDS? OR WAS IT THE MIDWIFE'S 'SNIP' THAT SET IT ALL OFF?

FIRST CUT

What we can tell you is that, from a very young age, our parents encouraged us to enjoy creative moments – and it was never about making the best drawing, or creating 'art'. It was all about the actual doing, enjoying the moment of creating and feeling involved in playful engagement. Creating became a way we could express something, and perhaps also get a word in in our rather big family. As twins, we had our own secret language until we were four years old, and we sometimes wonder whether papercutting was a way to express ourselves without words.

When we started Edition Poshette, through which we design handmade leather objects from bags to wallets inspired by the literary universe, paper became the natural accompaniment to our products. We began to cut and fold books and paper to decorate our products when they were exhibited in showrooms, and from there our paperwork has evolved to become an important part of what we do – but we are happy to say we have remained as playful with it as when we were kids. These days, we run many papercutting workshops, where we encourage participants to express themselves through cutting and folding. At every workshop, we hear: 'Oh, I'm not creative,' or 'I could never do that, I don't have the skill'. But that isn't the focus of our workshops, or this book.

THE POINT IS NOT TO CREATE AN ELABORATE SHOWPIECE, OR TO SHOW OFF YOUR SKILLS. IT'S ABOUT TAKING YOUR TIME TO DO YOUR THING, WITHOUT WORRYING ABOUT WHAT ANYBODY ELSE THINKS OF IT. WHATEVER YOU CREATE, WHATEVER YOU CUT, IT'S YOURS. YOU MADE IT.

So, before we dive in, perhaps we should start off with setting a few things straight.

1 » **EVERYONE IS CREATIVE.**

2 » **CUTTING AND FOLDING HAS NOTHING TO DO WITH HAVING A SPECIAL GIFT. IT IS ABOUT HAVING THE COURAGE TO HAVE A GO AT IT.**

3 » **PRACTICE IS THE REAL 'GIFT'. WE ONLY HAVE OUR SPEED AND EASE BECAUSE WE HAVE BEEN DOING IT FOR A LONG TIME, NOT BECAUSE WE HAVE A SPECIAL GIFT THAT YOU DON'T. SO START CUTTING, AND CUT AGAIN AND AGAIN. YOU WILL SOON DISCOVER THAT IT WON'T TAKE MANY TRIES BEFORE YOU ARE ABLE TO CREATE SOMETHING REMARKABLE – AND REMEMBER, IT'S JUST A PIECE OF PAPER.**

4 » **ALL YOU NEED IS PAPER AND SCISSORS. THE RIGHT PAIR OF SCISSORS IS THE PAIR YOU FEEL COMFORTABLE WITH. WE HAVE WORKED WITH CHEAP SCISSORS THAT WORK BRILLIANTLY. THEY MAY NOT ALWAYS BE AS PRETTY AS OUR FAVOURITE STORK EMBROIDERY SCISSORS (THEY ARE SMALL AND POINTY AND NICE TO LOOK AT), BUT AS LONG AS THEY ARE COMFORTABLE IN YOUR HANDS, THAT IS ALL YOU NEED.**

EVERYONE MAKES MISTAKES

It's inevitable that you'll make a mistake at some point. It happens all the time – an unplanned 'snip', a slip of the scissors, and you may inadvertently behead a paper doll. But don't let this put you off. When we feel discouraged because of a mistake it stops the flow of creativity. So try to do as a child would and just keep going, and going… and then go a bit further! Let your 'mistake' lead you in a new direction, deviate from what you were expecting to create and see where it takes you. The flaws and imperfections are often what makes the finished product so pleasing. The result may be great or it may just 'be a piece of paper' – it doesn't really matter. The beauty is in the making, in the journey you take while doing and creating.

CUTTING BY NUMBERS

We've included lots of ideas in this book, but the focus is not about making a perfect copy of our design. It's about being inspired to make and create your own story. There are templates for some of the projects, which you can trace or cut out, but they're simply the jumping off point. Once you grow in confidence, you won't need them – so invent your own.

ONCE UPON A TIME

STORY LIFE

> Cut-out butterflies
by Hans Christian Andersen.

ES WAREN EINMAL

DER VAR ENGANG

PAPER PARABLES

A papercut can tell a story. When Hans Christian Andersen told his stories he would papercut at the same time, and once he got to the end of his tale, he would unfold what he had been cutting. He literally brought the paper to life. Had he cut out two dancing ballerinas he would blow on them gently so it looked like they were actually moving, enchanting his audience by the pure magic of such a simple gesture.

POETRY OF THE PEOPLE

Like Hans Christian Andersen, the Brothers Grimm were great storytellers. Perhaps because they were siblings who worked together and created together, we find inspiration in their work. Through their rich plots and beautiful language, they not only told fairy tales but also taught us things about ourselves, and how we should live. Just like H.C. Andersen, the Brothers Grimm used papercuts as illustrations to bring their stories to life. Their fairy tales are often referred to as 'poetry of the people', and in them we find people who are humble and grateful, who use their hands, who create with skill and find their good fortune in the simple things in life.

↗ *Portrait of Hans Christian Andersen.*

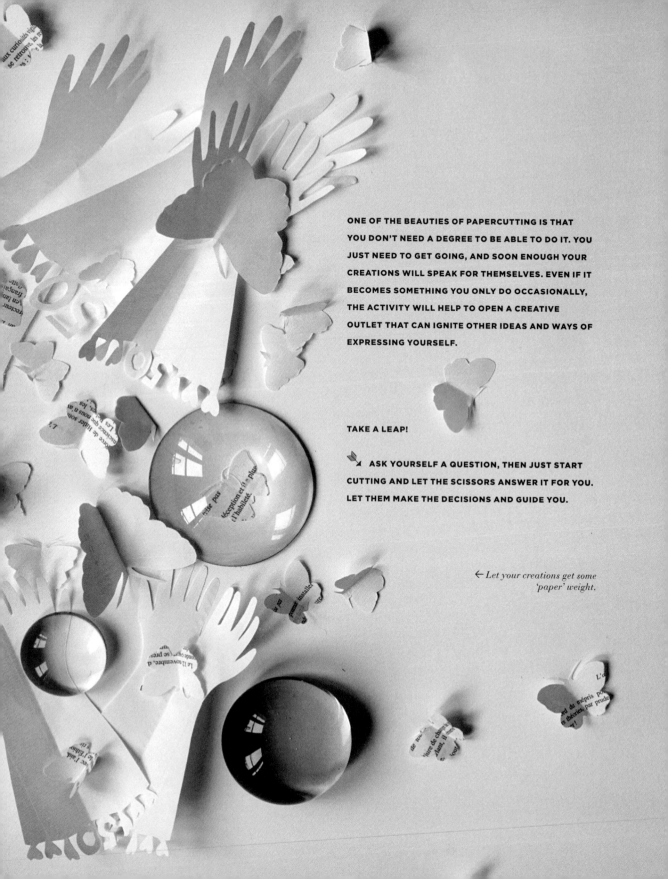

ONE OF THE BEAUTIES OF PAPERCUTTING IS THAT YOU DON'T NEED A DEGREE TO BE ABLE TO DO IT. YOU JUST NEED TO GET GOING, AND SOON ENOUGH YOUR CREATIONS WILL SPEAK FOR THEMSELVES. EVEN IF IT BECOMES SOMETHING YOU ONLY DO OCCASIONALLY, THE ACTIVITY WILL HELP TO OPEN A CREATIVE OUTLET THAT CAN IGNITE OTHER IDEAS AND WAYS OF EXPRESSING YOURSELF.

TAKE A LEAP!

ASK YOURSELF A QUESTION, THEN JUST START CUTTING AND LET THE SCISSORS ANSWER IT FOR YOU. LET THEM MAKE THE DECISIONS AND GUIDE YOU.

← *Let your creations get some 'paper' weight.*

WHY PAPER?

The magic of papercutting is that you don't need any fancy equipment – just a pair of scissors and your imagination. And you don't have to go and buy special paper, either – there is already so much around you, from a plain piece of A4 to a book you no longer need, or packaging, wrapping paper, letters or a bank statement. Use what you have and transform it – give it a whole new lease of life, from tree to paper to a piece of poetry.

We are used to the idea of using paper to write on, but when we cut or fold it, we discover a new way of using paper to express ourselves – with or without words. It's a way of 'cutting our thoughts out' and then turning those thoughts into stories. Because of the time and care it takes to cut, whatever we say through paper is somehow well considered, full of emotions and quite often poetic.

There are amazing paper artists out there who have perfected the art of papercutting, but our aim is to inspire EVERYONE to have a go at it. We hope that this book will help you discover how enjoyable and decorative it can be, and how it can help you find new ways of dealing with 'waste' by creating something beautiful out of it.

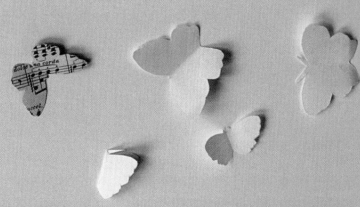

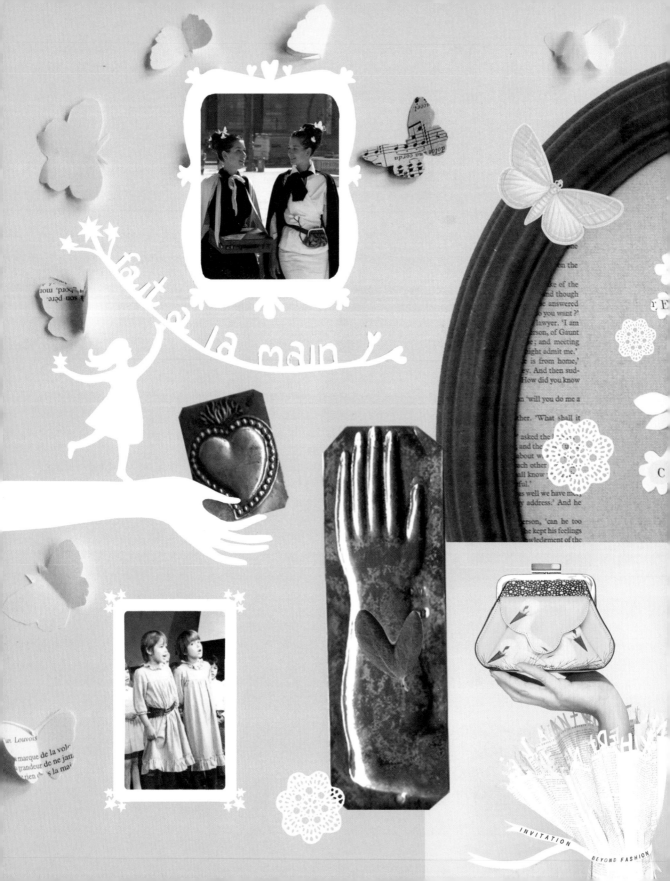

fait à la main

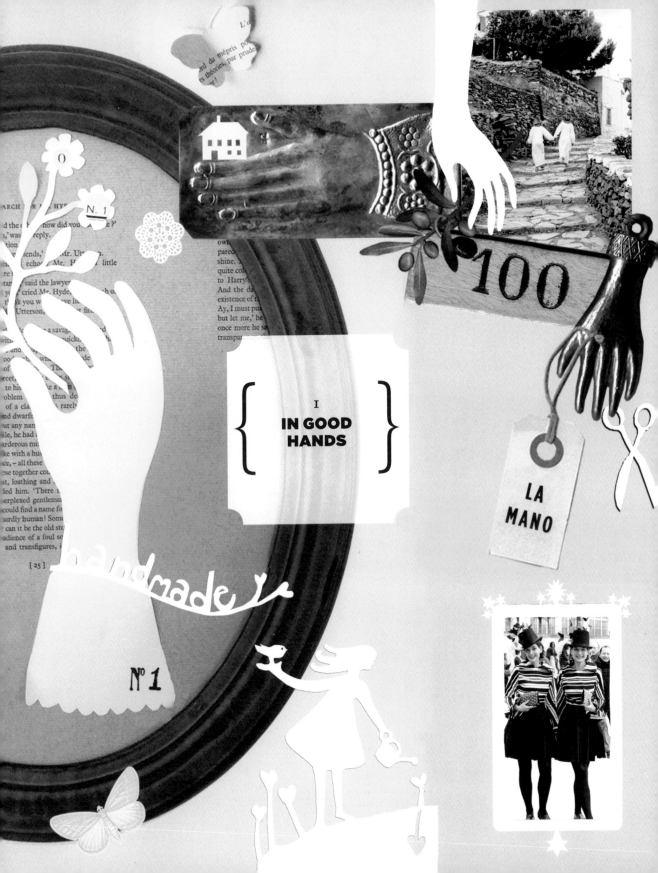

{
I
IN GOOD HANDS
}

100

LA MANO

handmade

Nº 1

HOW TO CUT

If you have never cut before, or if you haven't done it for many years, start with something simple. There's no need to dive straight in to a complex project that might leave you feeling disillusioned or frustrated.

By starting simply, you will soon discover how easy and, more importantly, how enjoyable it is to cut and fold.

We usually cut with scissors, and that's what we recommend you do, too – at least to begin with. (See page 63 for cutting with a scalpel).

Start by 'picturing' what you are going to cut out. It may not end up exactly like that, but if you have a picture of it in your mind you are already halfway there. Sometimes if we haven't cut for a while, we just need to warm up to get going. So get comfortable and start with something easy, like a feather (page 94), just as a warm up.

Once you have a few feathers in your cap, you can try some different ideas. Trace one of the swallows on page 75 or the dove on page 45 (or draw your own), then place it on top of one or two layers of thin paper (80–90 gsm) and start cutting, following the shape on the top layer.

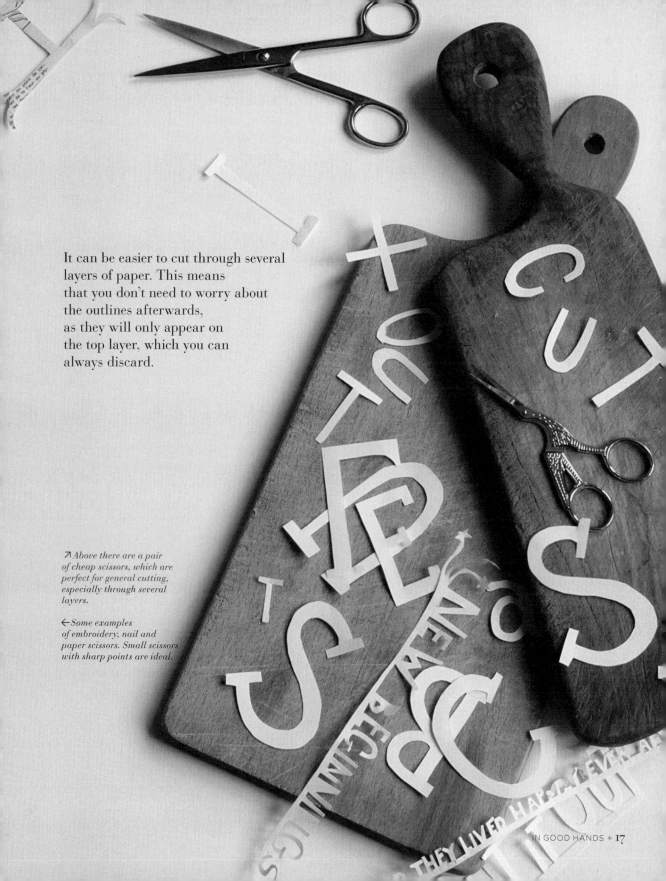

It can be easier to cut through several
layers of paper. This means
that you don't need to worry about
the outlines afterwards,
as they will only appear on
the top layer, which you can
always discard.

↗ *Above there are a pair
of cheap scissors, which are
perfect for general cutting,
especially through several
layers.*

← *Some examples
of embroidery, nail and
paper scissors. Small scissors
with sharp points are ideal.*

FIND YOUR RHYTHM

Everyone cuts in their own way. Even though we are twins, we don't cut in an identical style. Take some time to find your own 'voice' – relax into it.

It's a good idea to start by finding a 'stable' position. Use your fingers to stabilise the blade of the scissors, so that it is only the top part of the scissors that moves. As you cut and change direction, try to move the paper as much as the scissors. That way you won't become awkward and tense as you cut and everything will move more fluidly. You need to look at what you're doing and use both hands, so we joke about how it's also a good diet to papercut – no eating or checking social media as you work! Just stay engaged with what you are doing. As you cut, you might find yourself lapsing into a sort of meditative state, where your mind becomes calm and clear. This is one of the many benefits of papercutting – it makes excellent therapy.

WHEN OUR HANDS AND MIND ARE ENGAGED IN AN ACTIVITY LIKE PAPERCUTTING, THE CONCENTRATION REQUIRED ENABLES US TO HAVE IMPORTANT THOUGHTS THAT WILL RISE TO THE SURFACE – BUT ONLY BECAUSE WE'VE LEFT AN EMPTY SPACE FOR THEM TO APPEAR. SO TRY IT – JUST GO WITH THE FLOW.

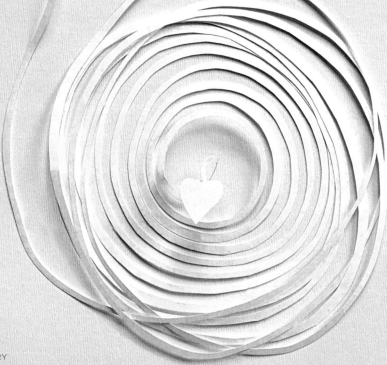

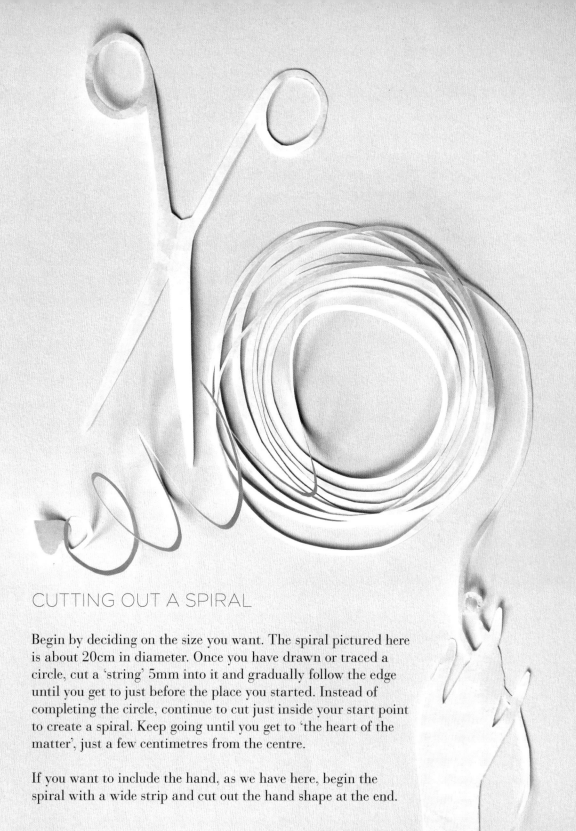

CUTTING OUT A SPIRAL

Begin by deciding on the size you want. The spiral pictured here is about 20cm in diameter. Once you have drawn or traced a circle, cut a 'string' 5mm into it and gradually follow the edge until you get to just before the place you started. Instead of completing the circle, continue to cut just inside your start point to create a spiral. Keep going until you get to 'the heart of the matter', just a few centimetres from the centre.

If you want to include the hand, as we have here, begin the spiral with a wide strip and cut out the hand shape at the end.

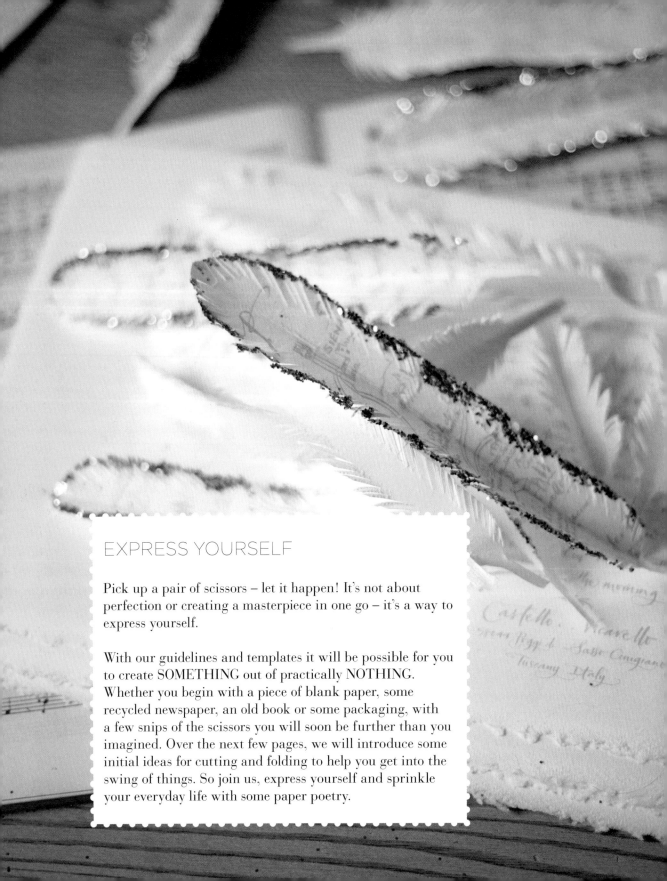

EXPRESS YOURSELF

Pick up a pair of scissors – let it happen! It's not about perfection or creating a masterpiece in one go – it's a way to express yourself.

With our guidelines and templates it will be possible for you to create SOMETHING out of practically NOTHING. Whether you begin with a piece of blank paper, some recycled newspaper, an old book or some packaging, with a few snips of the scissors you will soon be further than you imagined. Over the next few pages, we will introduce some initial ideas for cutting and folding to help you get into the swing of things. So join us, express yourself and sprinkle your everyday life with some paper poetry.

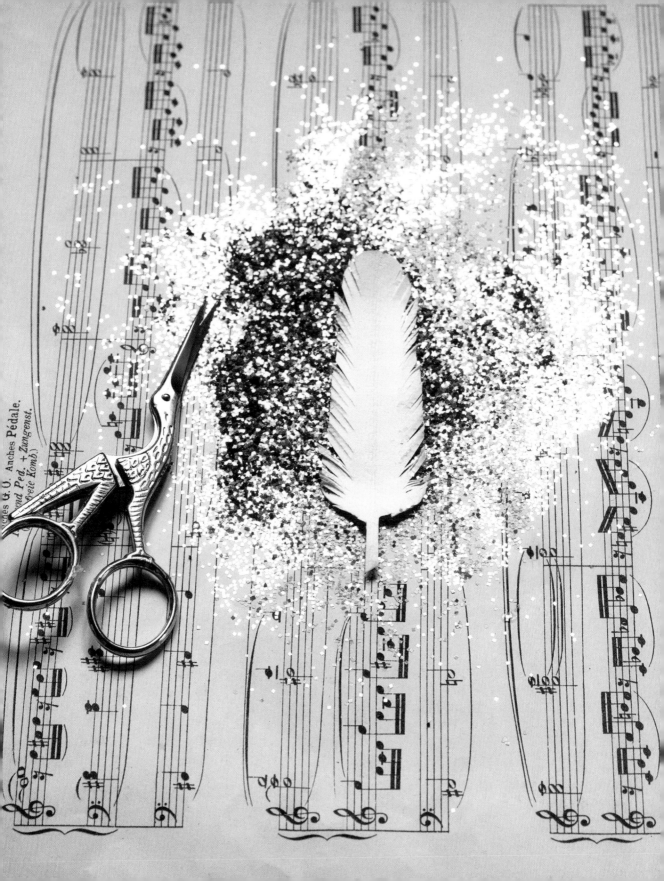

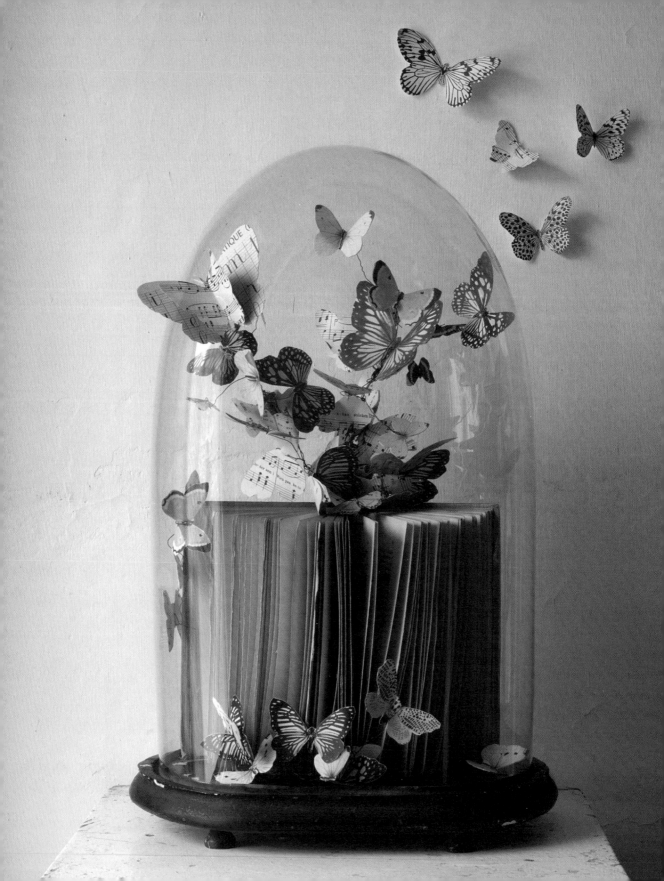

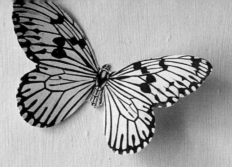

THE BEARABLE
LIGHTNESS OF BEING

Paper is light and strong at the same time. As you begin to work more with paper, you will discover that there are many different weights, from creamy, thick, luxurious paper to super-fine, almost transparent tissue. The thickness of paper is given as a weight (gsm). The higher the gsm, the thicker the paper. When we're working with thinner paper, we like to cut several layers at a time, not only because it's faster but because the resistance between the paper and scissors is easier to work with when there's something thicker to cut through. If you're working with thicker paper, though, only cut one layer at a time.

To cut up a butterfly, fold a piece of paper and cut it into the shape of half a butterfly, centred on the fold, as shown in the illustration. Open it out, and *voilà*. By the time you've cut up 10, you will have invented your own 'perfect' butterfly.

← *Butterfly book in a bell jar.*

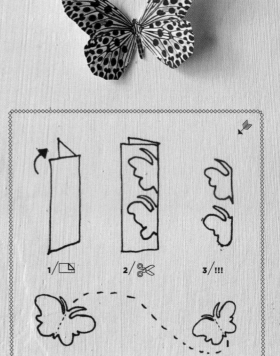

1/ ▱ 2/ ✂ 3/ !!!

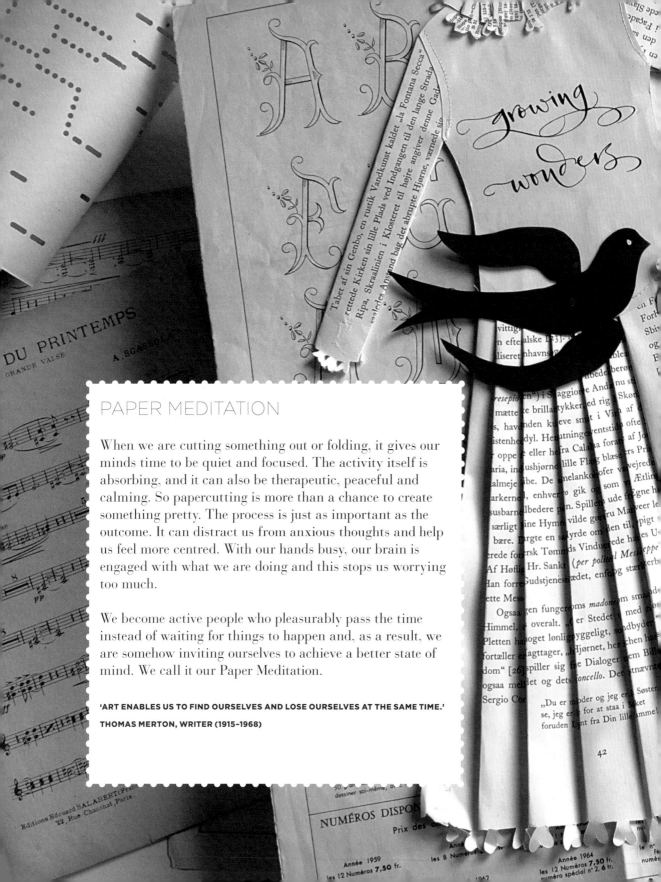

PAPER MEDITATION

When we are cutting something out or folding, it gives our minds time to be quiet and focused. The activity itself is absorbing, and it can also be therapeutic, peaceful and calming. So papercutting is more than a chance to create something pretty. The process is just as important as the outcome. It can distract us from anxious thoughts and help us feel more centred. With our hands busy, our brain is engaged with what we are doing and this stops us worrying too much.

We become active people who pleasurably pass the time instead of waiting for things to happen and, as a result, we are somehow inviting ourselves to achieve a better state of mind. We call it our Paper Meditation.

'ART ENABLES US TO FIND OURSELVES AND LOSE OURSELVES AT THE SAME TIME.'
THOMAS MERTON, WRITER (1915–1968)

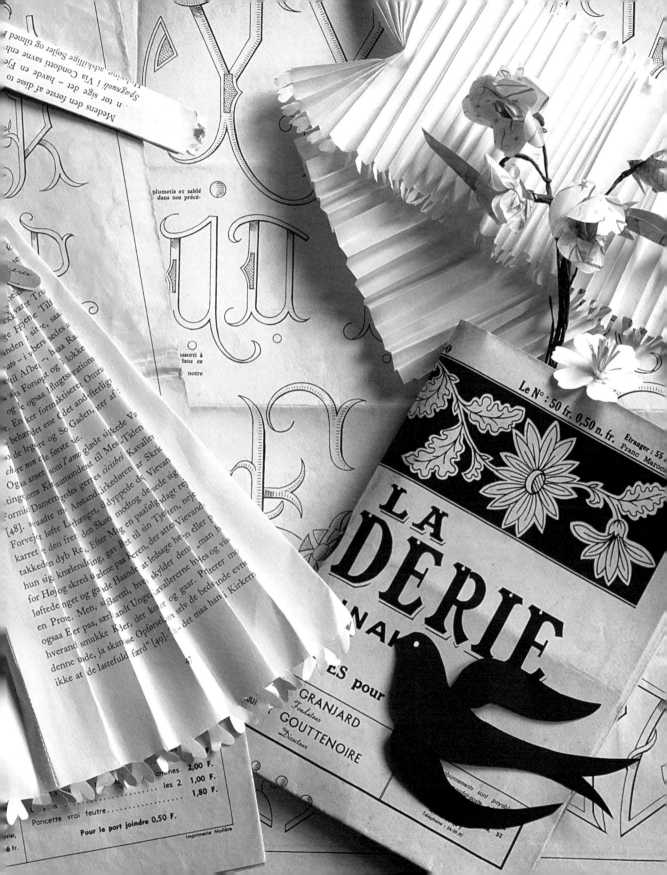

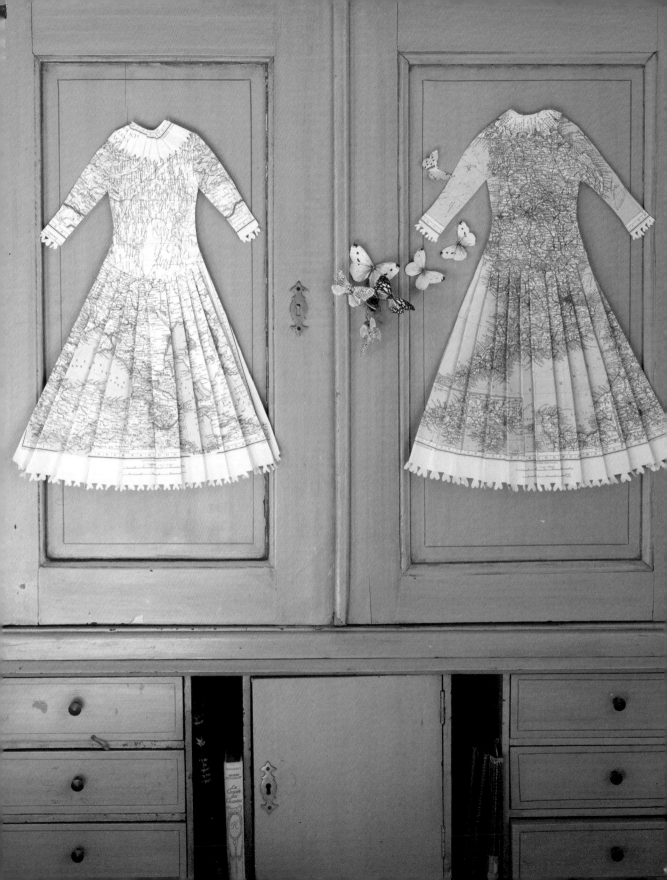

PAPER DRESSES

Seamstresses often make a mock up, or toile, in paper before they start sewing a garment in any expensive fabric. It's a lighter way to try something out. We thought it would be fun to make dresses out of different kinds of paper, not to wear but to hang up. Sewing in paper gives us great satisfaction and we use it a lot to finish off our paper 'work'. You can just use a normal needle – it will bite satisfyingly into the paper.

These dresses are among our favourite creations, but they are quite difficult to make – even explaining how to make them is complicated! Once you have tried out some of the projects in this book, you might want to try to make your own paper dresses, so we have included details of our instructional video below. For now, we hope these will serve as inspiration for how you can use paper in all sorts of ways and how decorative it can be when used to transform old book pages, maps, letters and give them a new shape and purpose.

[*For a video of this project, visit our YouTube page, Paper Poetry, and watch 'Helene and Simone's Pleated Paper Dressmaking'*]

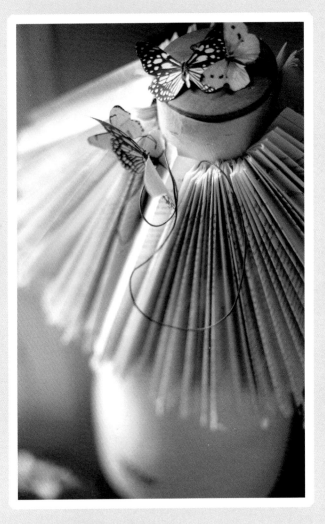

{
II
**SAY IT
WITH PAPER**
}

PAPER
WISHES

From declarations of love to best wishes for birthdays, holidays and special days, everything you want to say can be said with paper. Over the next few pages you will find a few ideas to get you going on your journey...

HAPPY NEW BEGINNINGS

Try this papercut as a sweet way to congratulate a friend on her pregnancy.

Trace this template and cut the woman and baby out, taking care with the finer pieces. *Biennaître* **is a play on words in French – it translates as 'well born', but is pronounced as 'well being'. You can change the words to your own message, or leave them out if you prefer.**

→ *When we were cutting out 'Mrs. Biennaître', we cut out two layers at the same time as we often do, and voilà! There we were... almost accidentally, twins joined to the umbilical chord in our mother's womb.*

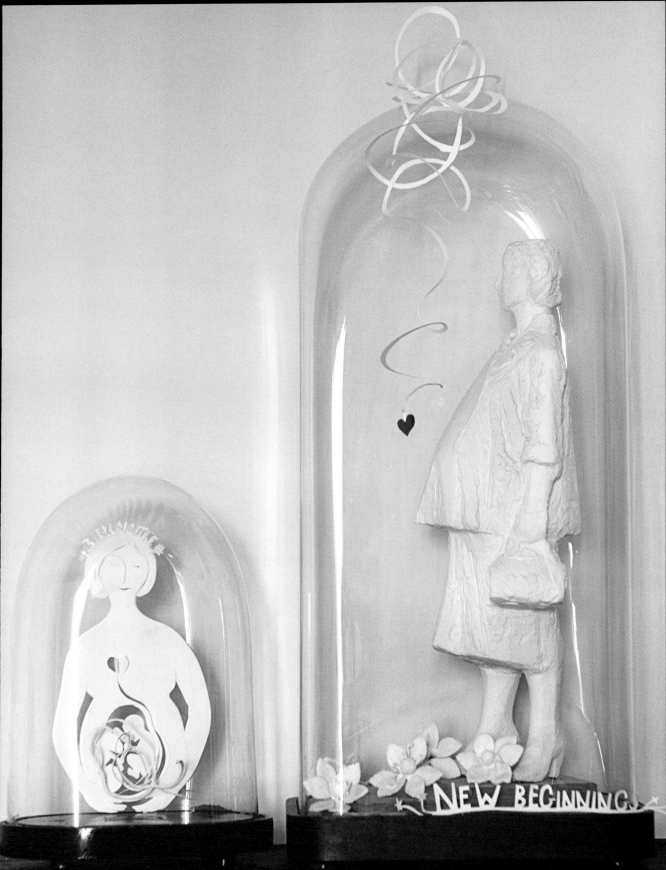

A BOUQUET OF
PAPER DAFFODILS

Transform sheet music, book pages and
old calendars into a bouquet of everlasting
daffodils. This will make a beautiful gift
to bring along to a party or dinner, with
the added advantage that the host will
not have to immediately disappear to put
them in water.

**EACH FLOWER WILL TAKE APPROXIMATELY 10–15
MINUTES TO MAKE, AND ONCE YOU HAVE MADE THE
FIRST FEW STEMS YOU ARE QUITE LIKELY TO SPEED UP.
THE WHOLE BOUQUET WILL TAKE ABOUT 2 HOURS.**

YOU'LL NEED

- YELLOW OR ORANGE PAPER, FOR THE STIGMA
- CREAM OR WHITE PAPER, FOR THE PETALS
 (WE THINK OLD SHEET MUSIC
 LOOKS ESPECIALLY BEAUTIFUL)
- GREEN PAPER, FOR THE LEAF
- THIN WIRE
- MASKING TAPE OR GREEN FLORAL TAPE
- SCISSORS

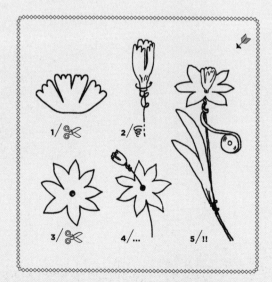

Start with the stigmas of the daffodils. It's
good to have something yellow or orange for
these, to contrast with the creamy colour of
the petals. We used the yellow cover of an old
book of road maps.

Cut out a rectangle measuring around 8x5cm.
Cut it into the shape shown in illustration 1,
stopping 1cm from the bottom so that the
whole thing stays together. Now roll this piece
of paper and wrap a thin piece of wire around
the bottom.

Now for the petals. Take the white or cream
paper, and cut out a circle measuring about
10–12cm in diameter. Now cut this circle into
petals, stopping before the centre so the
paper stays in one piece. We think the end
result is better if you just cut, rather than
trying to use a template, as it means that
every flower will be slightly different, just
like in nature. Poke a hole in the middle of the
petal layer and push the wired stigma through
the hole. Either put a bit of masking tape onto
the paper and wire to fix it, or wrap another
thin piece of wire around the stem.

Now wrap masking tape or green floral tape
around the stem and cover the wire. Cut out
a leaf shape from green paper and attach it
to the stem. Continue until you have as many
flowers as you want for your bouquet.

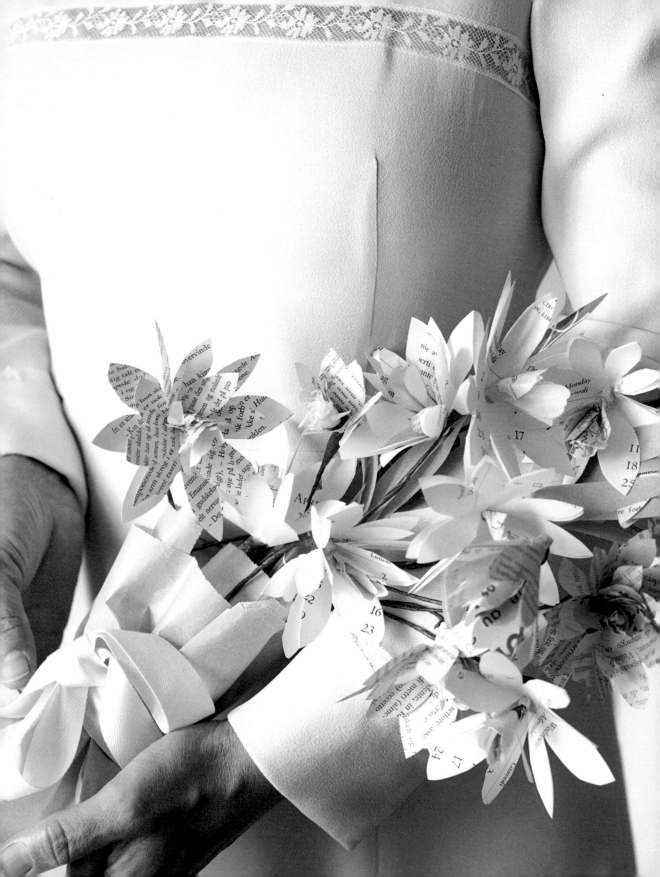

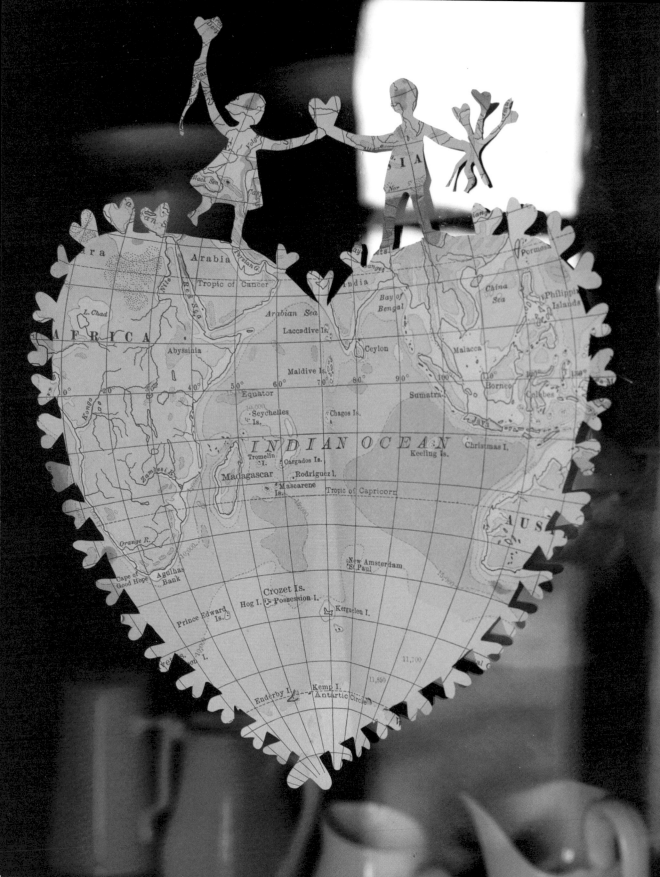

LOVE MAKES THE WORLD
GO ROUND

Cutting these paper hearts from a map
is a lovely way to send your love around
the world. Or you can use plain paper
so you can write a message onto it.
If you are using thin paper, you can cut
several at the same time.

✍ Trace the heart shape in the photo
on the left page. Fold the paper in half so you
are effectively cutting the two halves
at the same time. When you reach the top
area, you'll need to open it up to cut the boy
and girl individually.

↘ Enlarge, trace and cut out the stork below.

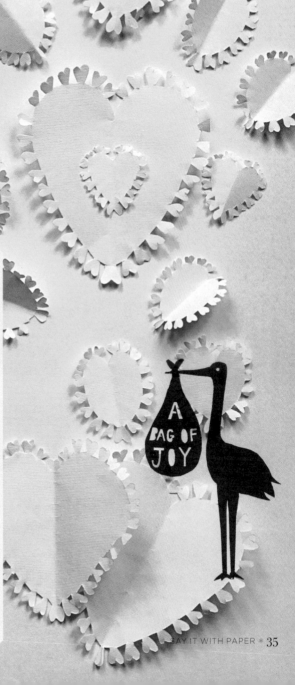

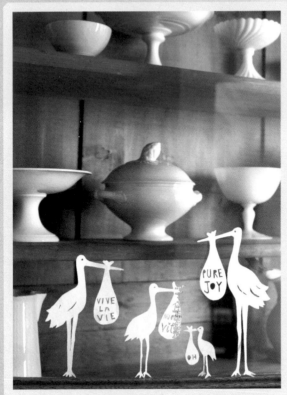

BEAUTIFULLY PRESENTED

Papercuts can make beautiful gifts, but also gift packaging. Re-purpose old paper, such as newspapers, maps and magazines to make colourful wrapping paper. Cut out pretty shapes to use as gift tags and give your presents personality.

↓ Send congratulations with a wreath made from paper flowers mixed with fresh green eucalyptus leaves. See pages 96–97 for how to make your own wreath out of recycled paper, and page 79 for how to make paper flowers. The eucalyptus leaves dry out beautifully, making the wreath a durable winner.

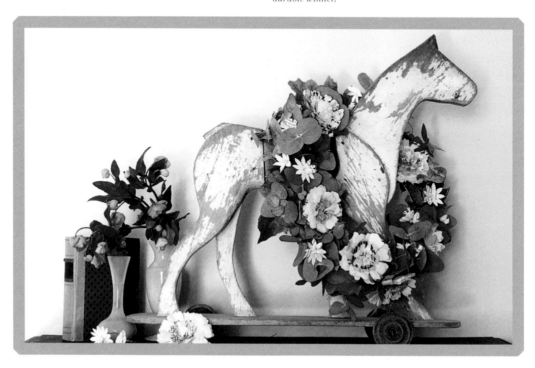

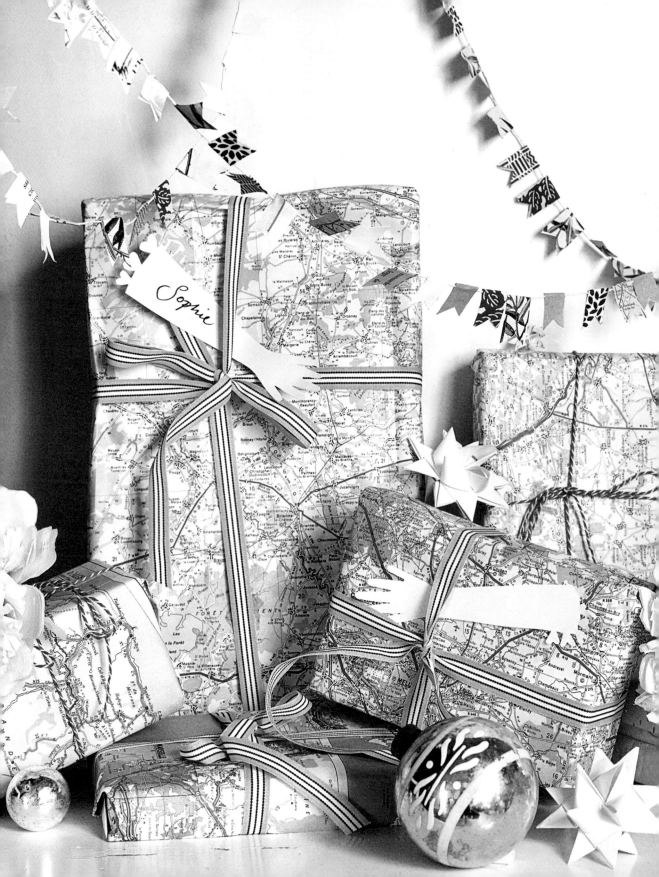

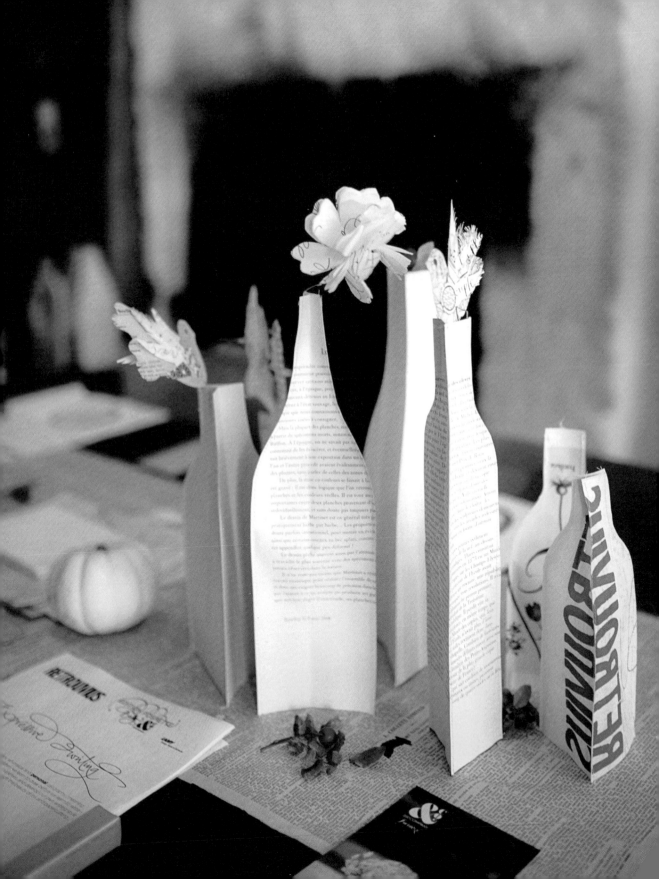

MESSAGE ON A BOTTLE

These paper bottles make wonderful vases for paper flowers or even fresh if you use them to cover a glass bottle. When flattened, they are perfect to send to someone as a message 'on' a bottle. We like to make them out of old book pages, or scraps of paper decorated with our friend Betty's beautiful calligraphy (see pages 48–49).

YOU'LL NEED:

- **THREE PIECES OF PAPER**
- **SCISSORS**
- **NEEDLE AND THREAD/SEWING MACHINE**

Cut out three identical bottle shapes from your paper. Use your needle and thread or a sewing machine to carefully sew them together, joining them into a 3D paper bottle.

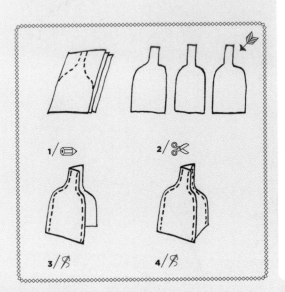

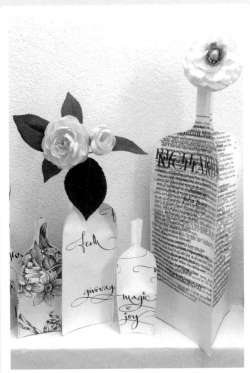

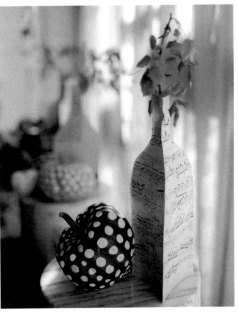

PAPER GREETINGS

Papercuts can be a charming way to welcome visitors to your home. Here we have two paper cut-out birds to greet you at the front door with a welcome message in each envelope.

⌁ **Use the photo on the right as a guide to draw your own welcoming bird, along with a greeting message on the envelope. Cut out and display wherever you want to make people feel welcome.**

HELPING HANDS

Hands have always fascinated us, and they are, of course, a vital ingredient when it comes to papercutting – so let's pay tribute to them with an array of helping hands to adorn and decorate.

⌁ **Turn to page 74 to trace the hand templates. Cut them out and thread them on a string to create a hanging display (see overleaf) or use them as gift tags or bookmarks.**

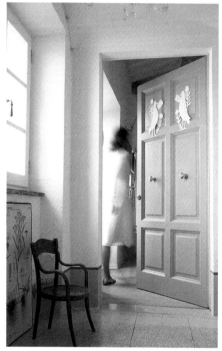

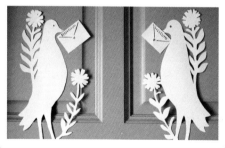

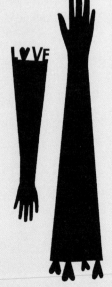

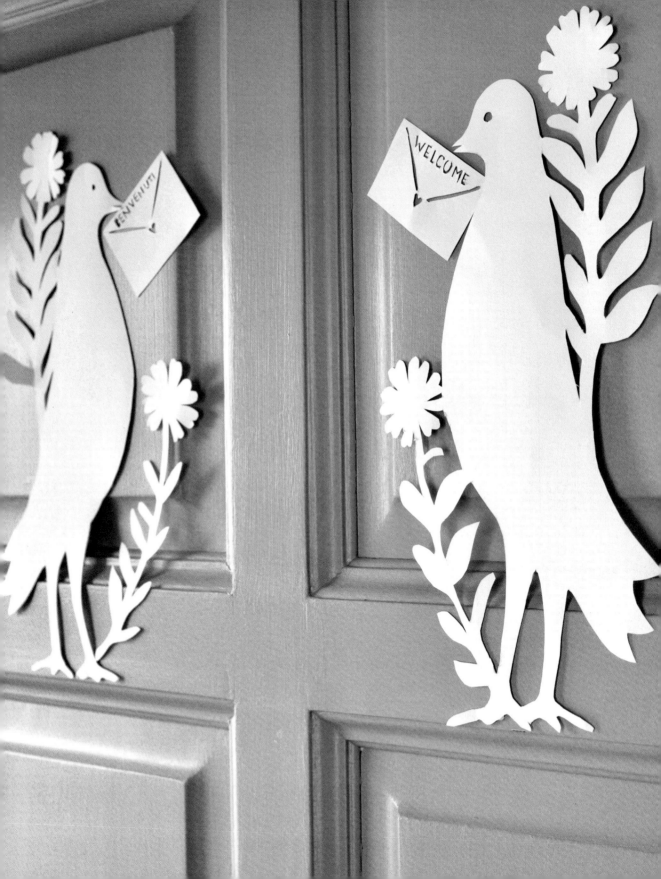

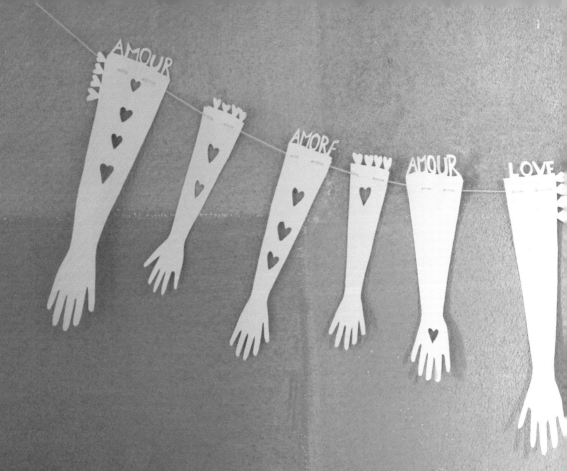

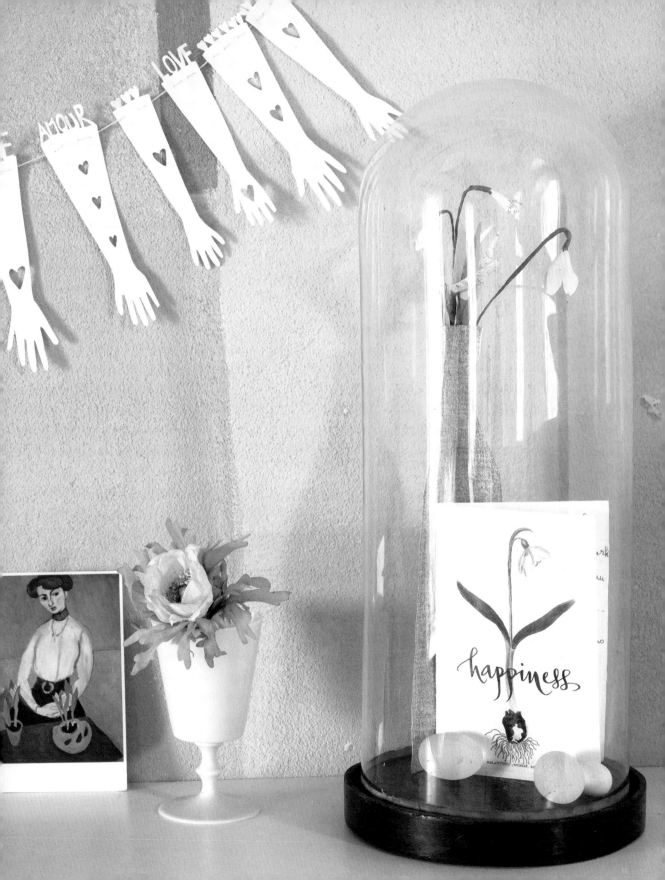

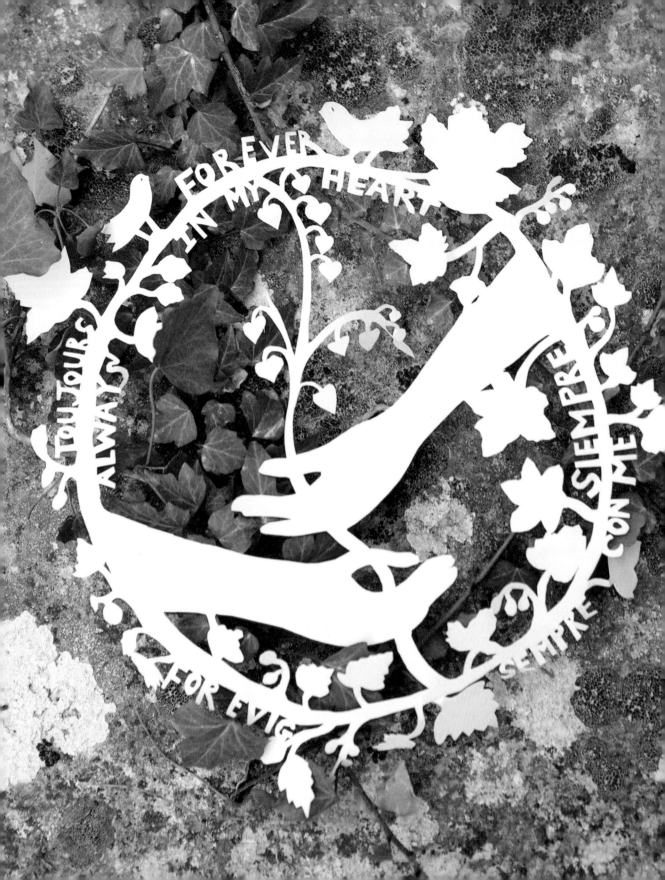

PAPER INTENTIONS

For those hard times in life when what we feel is deeply painful, words do not always suffice. Instead, try expressing yourself in fragments in a piece of cut-out paper poetry formed into a wreath of words to tell someone dear how you feel. The time spent creating will bring you a moment of peace to help that pain gently fade with time, and the gift will show the thought you have put into it. If the wreath is too complicated, a dove bringing joy, comfort, hope, or love may just be the very best way to show your good intentions.

Use the photo on the left as a guide to create your own wreath, or trace the doves below and cut them out.

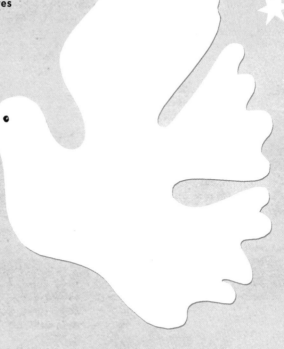

HERE

PAPER STORIES
TO SURVIVE YOU MUST TELL STORIES

CARTA CARTR

STORIES

{ III
**PAPERBACK
WRITER** }

WORKING WITH WORDS

IF OUR LAST CHAPTER WAS ALL ABOUT USING PAPER TO SAY THE THINGS THAT WORDS CAN'T, THIS CHAPTER IS ABOUT USING PAPERCUTTING TO ENHANCE AND CELEBRATE WORDS. FIRST, WE'D LIKE TO INTRODUCE YOU TO SOME OF THE INCREDIBLE ARTISTS WE HAVE COLLABORATED WITH OVER THE YEARS, AND INSPIRE YOU WITH DIFFERENT WAYS TO USE WORDS IN YOUR PAPER CREATIONS.

INKTRODUCING BETTY SOLDI

How lucky we are to have had the good fortune to cross paths with Betty Soldi. She is not only the incredibly talented calligrapher behind the beautiful book *Inkspired*, she has also become a dear friend and our numerous collaborations with her are the inky icing on our paper cake.

Betty's beautiful calligraphy is one of our favourite things to work with. We love to use her cards and letters as the paper we cut into flowers, feathers and butterflies. The flow of the calligraphy adds another element of beauty to the shapes we cut, and the snippets of sentences and words that are captured are given new importance.

GENEROSITY

Betty is always so generous, not only with her calligraphy but also with her time. We'd like you to be inspired by this generosity and be generous with yourself. Give yourself the time to play with paper and free up your own creativity. Use paper with words on it, from old love letters to shopping lists, and see the new meaning that is given to them when they are transformed by scissors.

TRUST

Betty always shows total faith in our abilities, and her trust in us enables us to create freely and confidently. Some of the photographs in this book come from the Paper Room at Betty's beautiful hotel in Florence, SoprArno. Each room is exquisitely decorated, and this room was entrusted to us by Betty. We decorated it with papercuts and snipped-up books, and what a joy it was to be given all that space and freedom. We hope that you can show this sort of trust in yourself and your hands – have confidence in your abilities, keep trying and keep cutting.

TOGETHERNESS

Whenever we work with Betty, we know there is no need to put pressure on one another. We do what we do because we love it. As we make, write, cut and fold, the three of us laugh together and share the joy of creating. We hope this can inspire you to bring the idea of sharing and collaborating into your own papercutting. Connect with friends and family, sit with them and create together. This will make your creations even more beautiful and personal.

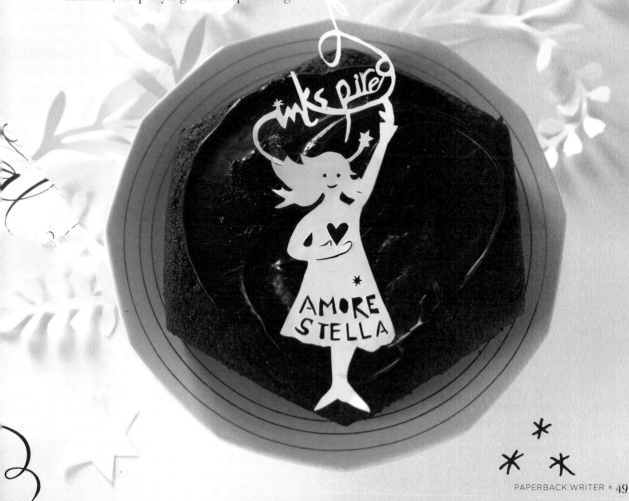

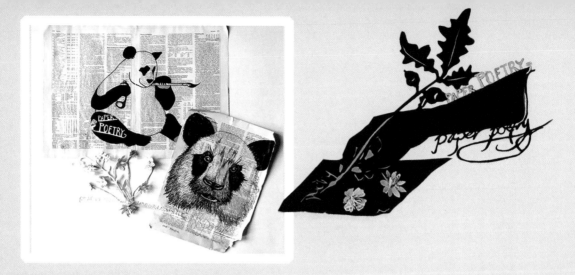

INTRODUCING
DAVID S.

When we first met David S., a street artist who uses papercut stencils to create his work, he thought papercutting was a bit lame. Well, in fact, in creating his stencils he was doing the opposite of what we do – he would cut the shapes that he wanted to spray paint into, whereas we would cut out what we wanted to be seen, removing the outline. Like a shadow and its light source, it's difficult to distinguish whether the cut-outs or what is left after having cut out is 'best' – somehow, they need each other, and perhaps it is almost irrelevant. For us, there is no doubt that David S. transforms paper into the most beautiful objects of art.

Whenever we talk about an idea he will, as if by magic, manage to pick up on the essence and apply his scalpel to butterflies, crowns, hearts, words, owls and birds – and always manages to give it some edge. Perhaps because paper has the same 'here today, gone tomorrow' effect as street art, it is a completely straightforward way for David S. to express himself. With a playful sense he explores the limits of paper and now he even cleverly cuts some of his papercuts out in wood, almost bringing the paper back to its original state.

David S. works with a scalpel, whereas we are more confident with a pair of scissors. His amazing cuts, with their tiny holes and refined details, show what such precision can produce. We find that scissors create a certain softness to our work, and provide a more portable way of working, you don't need a cutting pad or even a flat surface, just snip away on a train, on the bus, in a waiting room.

David S. cut ridiculous amounts of butterflies out of an old book, adding 'butterfly' in Betty Soldi's calligraphy.
When we opened it, it was as if all the poetry fluttered out of it (see overleaf) ↘

ONE WAY OR THE OTHER, THE PAPER BECOMES THE MEDIA AND THE TOOL IS BASICALLY WHATEVER YOU PREFER – PEN, SCALPEL OR SCISSORS.

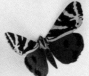

Paper Poet

ONE PANDA.

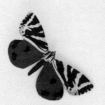
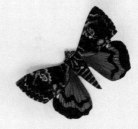

Polly

ONCE UPON A TIME

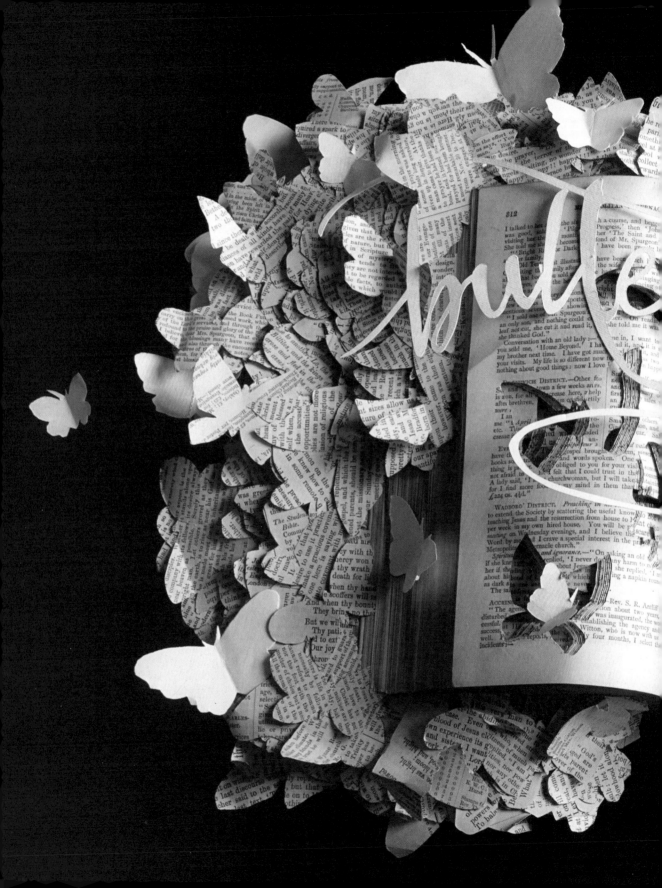

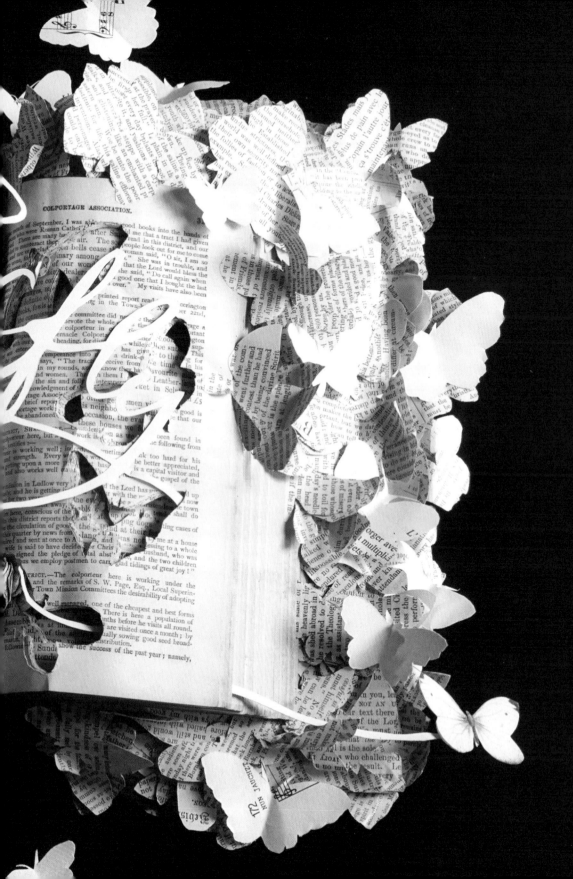

WORDS MATTER

Of course, you don't need to have beautiful calligraphic handwriting or be especially skilled with a scalpel to use words in your papercuts. You can use your own handwriting, writing out the letters first (block capitals are easiest to begin with), or just cutting them out freehand.

WISE WORDS

Cutting out phrases can give them new meaning, and you can use them in a number of creative ways. Think of your favourite words and sayings and give them a new life.

If you want to keep a whole word or sentence together in one piece, include a line at the bottom of your papercut so that all the letters are connected to it. You can turn these words and phrases into decorations for your home by hanging them from ornaments and lampshades or arranging them on surfaces and walls.

← *A wise owl with a wreath of well-chosen words around its neck in front of a photo of the wonderful Louise Bourgeois.*

→ *A bust of our Aunt Pia, by her husband Knud Nellemose. Surrounded by artists, she always picked her words with great diplomacy and elegance.*

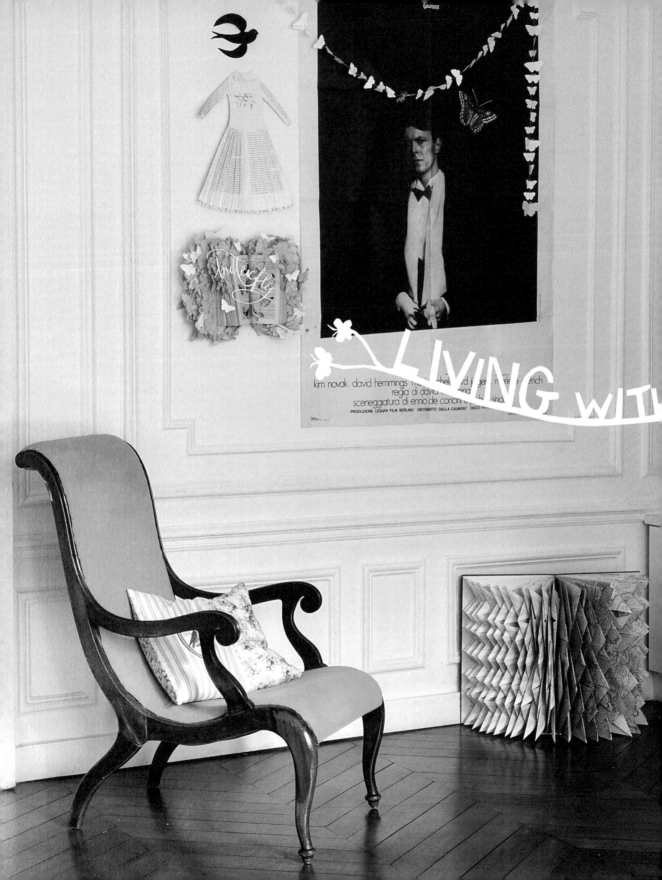

PAPER here there and HERE&There& everywhere

{
IV
LIVING
WITH PAPER
}

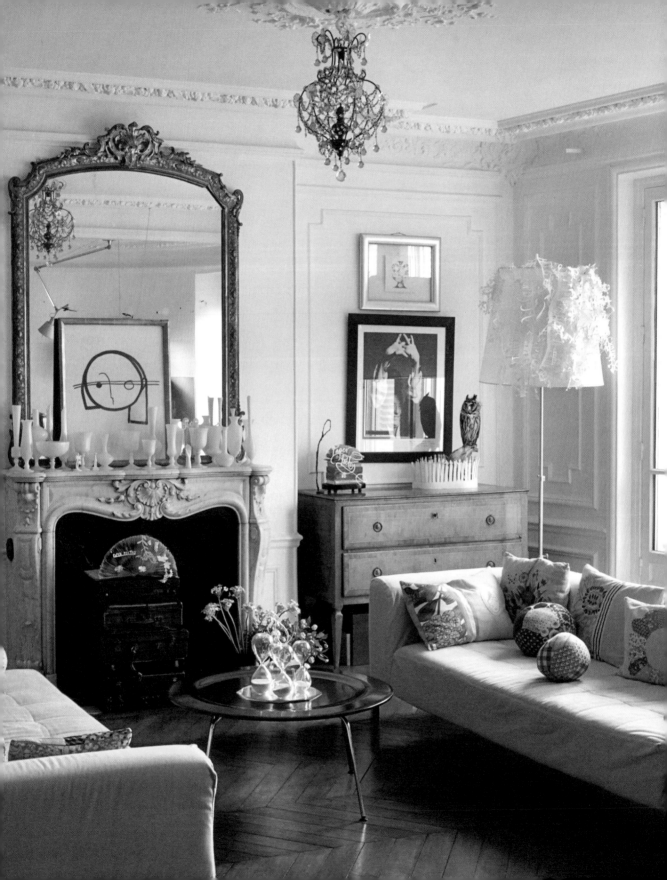

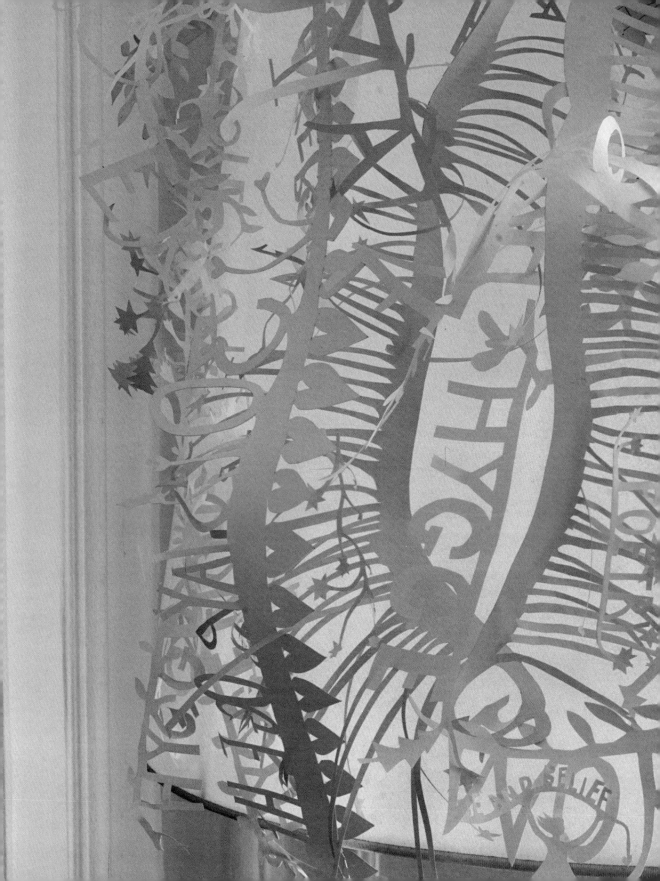

AT HOME
WITH PAPER

**PAPER OFFERS A QUICK AND INEXPENSIVE WAY
TO REDECORATE YOUR HOME, WHETHER
YOU WANT TO REFRESH ONE ROOM OR GIVE THE WHOLE
PLACE A NEW FEEL.**

BUNTING, BANNERS AND GARLANDS

Papercut bunting gives a festive feel, and
you can use different papers and shapes
for different occasions.

➤ **Choose lots of different colours of paper
and decide on the size of your bunting. Draw
the flag shape on a folded piece of paper and
cut it out. When you've finished cutting each
flag, glue them together on a length of string.**

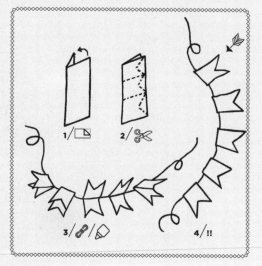

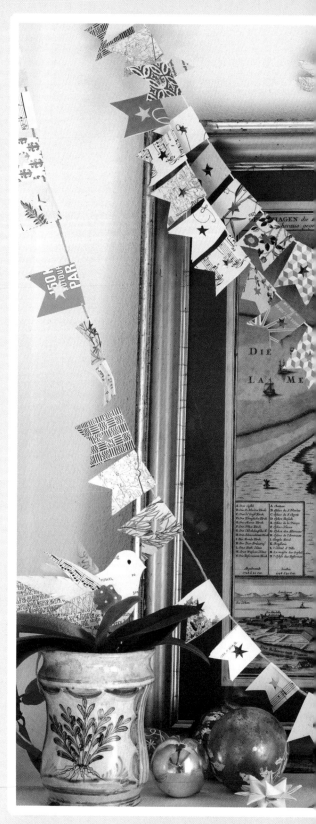

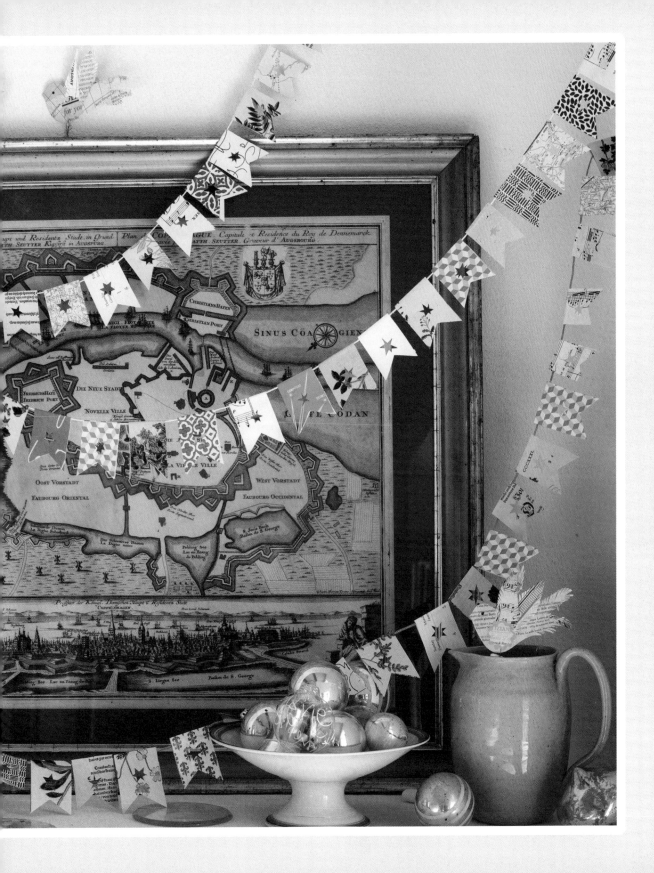

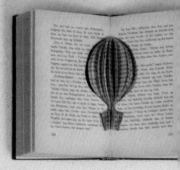

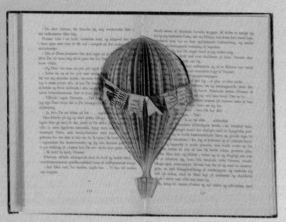

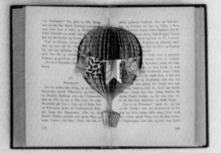

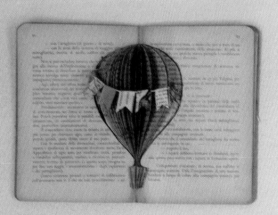

→ *Hanging hot air*
book balloons on a wall.

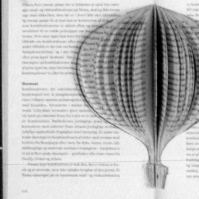

CUT BALLOONS

For this project, it's easiest to use a scalpel. As with a pair of scissors, remember you are in control of the knife and not the other way around, so take your time and cut when you are ready.

➤ **Place a template of your cut-out hot air balloon that fits the size of your chosen book, more or less halfway through the book in the middle of a double spread. Carefully cut around the outline, keeping the knife's blade at a slant as if it were a pen. Put quite a lot of pressure on the knife (keeping your other hand steady and out of the blade's reach). Cut through as many pages at once as you can – you can even go back into the same cut several times. Once the whole outline is cut out, lift the pages up and let the hot air balloon fly. Cut about half of the book's pages to achieve the desired effect.**

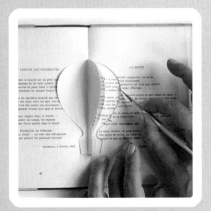

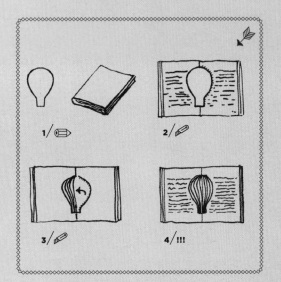

1/✏

2/✏

3/✏

4/!!!

Export af Klid fra København
angivet i Millioner ℔.

Aar	København nden Frihavn	Frihavnen	Jalt	heraf S
1897.	10, 0.	3, 3.	13, 3.	
1898.	15, 1.	3, 8.	18, 9.	
1899.	15, 8.	7, 7.	23, 5.	
1900.	13, 5.	8, 2.	21, 7.	
1901.	10, 9.	9, 3.	20, 2.	
1902.	6, 6.	23, 0.	29, 6.	29, 6
1903.	9.	19, 0.	28, 0.	28, 0
1904.				
1905.				

	Exp.	12,8	0,6
1904.	Imp.		
	Exp.		
1905.	Imp.		
	Exp.		

L'ÉTRANG

bien avec le reste de mon ten
pensé alors que si l'on m'
dans un tronc d'arbre sec, sa
tion que de regarder la fleur
de ma tête, je m'y serais p
tué. J'aurais attendu des pa
ou des rencontres de nuages
dais ici les curieuses cra
avocat et comme, dans un
patientais jusqu'au samedi
le corps de Marie. Or, à b
n'étais pas un arbre
plus que moi
leur de mam
répé qu'on finissait par s'habi-
tuer à tout

Du reste n'allais pas si loin d'ordi-
naire. Les p ers mois ont été durs. Mais
justement t que j'ai dû faire aidait à
les passer exemple, j'étais tourmenté
par le dé ne femme. C'était naturel,
j'étais jeu ne pensais jamais à Marie
particulièr Mais je pensais tellement
à une fem ux femmes, à toutes celles
que j'ava ues, à toutes les circons-
tances où ais aimées, que ma cellule
s'emplissa ous les visages et se peu-
plait de irs. Dans un sens, cela me

110

HO SOGNATO DI TE
BEGUINE

pediment the tale is carried on. The destiny of the nascent city and
is to be determined. Is Athens to become a votary of Poseidon? Is
ways of the sea, to be devoted to commerce, to strive after a pros-
ainly material? In part she must take this course. Material neces-
purposes, as they do the purposes of all cities. Men must live, and
too fertile Attic land they must increase their natural resources by
by trade. But still the city is not to be the city of Poseidon. In spite
ities she shall remain true to her higher calling. Even her material
ll be controlled by Athena Ergane, the mistress of the workers. If
not be by merely supplying the grosser needs of men.
e connected with their higher activities. She shall pro-
pple the limbs of athletes and to feed the lamps which
ods. Her honey and her figs shall have something of the
light Athenian air. She shall supply the most beautiful
building and for carving. And one of her chief produces-
ses, in which she has almost a monopoly in the ancient
preserved to us in such abundance in the tombs of Italy

this, Athens is to be the city of arms and of courage, of
song and the drama, of thought and wisdom. What Athena is in Olympus, Athens is

nattentil 16.10.1978.

ller på cycle —
til højre ligger
er fortov og
ej og fortov
inad mig

WHEN WALLS TALK

Recently, we were asked to renovate a rundown summer camp outside Copenhagen for children with special needs. There was a very tight budget, so we had to come up with inventive and sustainable solutions. We decided to wallpaper each room using a different kind of paper. In one room we used old comic books, in another old maps, and in the hallway we used old dictionaries. This gave each room charm and interest, and let the walls tell stories, giving the children a more stimulating environment than plain old walls. When we surround ourselves with something that is both decorative and meaningful, it has a great effect on our well-being.

Watching the children who have spent time there since we finished the renovation has been quite a discovery. Although some of these children struggle with feelings of frustration and anger that they sometimes take out on their surroundings, they have been incredibly respectful of what we have presented them with, especially those things that were done in paper.

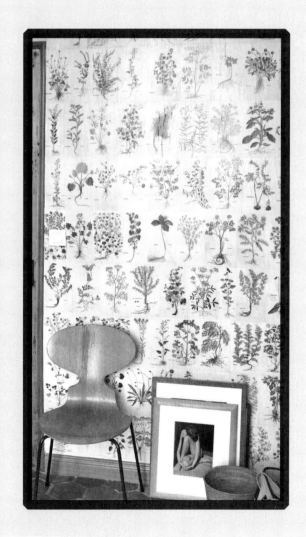

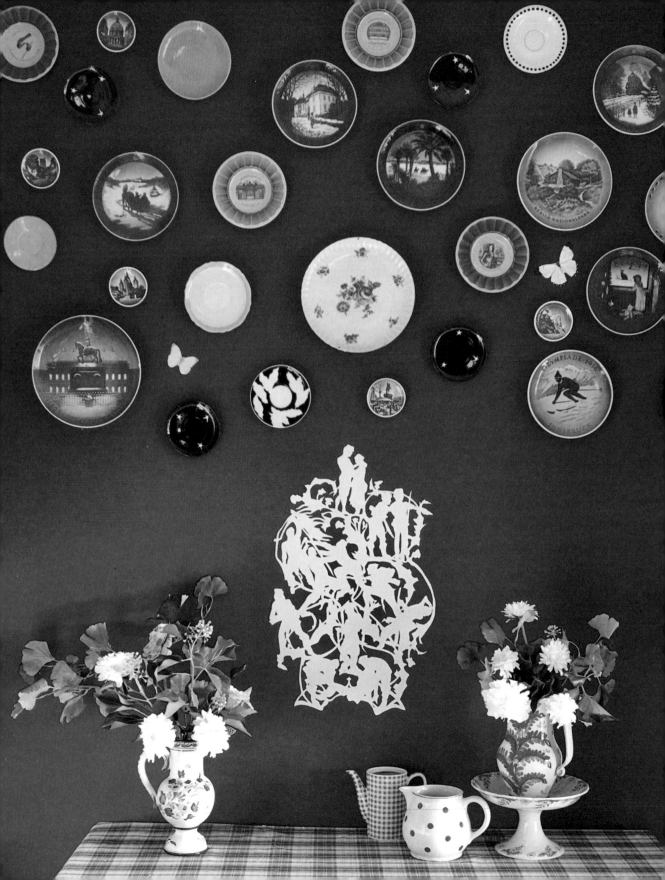

☛ Elements like butterfly curtains, paper dresses and the wallpaper have been carefully looked after and admired by the children. Perhaps this is because they can see that these things are valuable because of the time spent on them. Perhaps it is because paper objects have a fragility that they don't want to damage. Perhaps it is simply because they are lovely things to be surrounded by.

There is an authenticity in paper and books that the children appreciate, sometimes more than we would imagine because we are so used to seeing them with digital devices or getting bored as soon as there is no internet connection.

HERE, THE PAPER BRINGS OUT A PLAYFUL CURIOSITY. THE CHILDREN SEARCH TO FIND WORDS AND THEIR EXPLANATIONS ON THE WALLS COVERED IN DICTIONARY PAGES, OR A FAVOURITE DESTINATION IN THE MAP ROOM, OR TO REVISIT A PARTICULAR COMIC STRIP.

→*A variety of maps and comic books used as wallpaper in bedrooms at 'Høve-Hus' in Denmark.*

← *An elaborate Hans Christian Andersen cut out by David S. wallpapered directly onto the wall beneath the blue porcelain plates.*

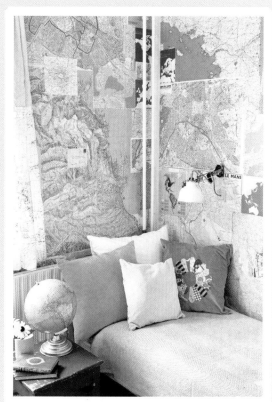

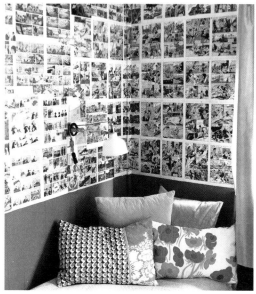

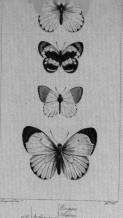
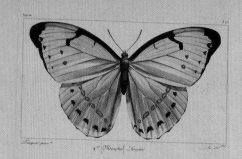
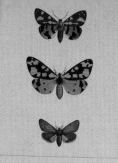

THE SMALLEST ROOM

It's just a piece of paper
a printed proof
a diploma
a last letter full of
motherly memories
a handwritten greeting
a flash of a photo
grandma's favourite
expression
paper gathered in the loo
so it doesn't
flush away

⌖ **Small rooms, like bathrooms and cloakrooms, can stand up to bold decor. If you like the idea of wallpapering a room with old paper, this is a good place to start.**

Gather up pieces of paper that hold memories or meanings, and use them to decorate the wall rather than hide them away in a drawer.

→ *Pages of poetry and a diploma used as wallpaper in the bathroom.*

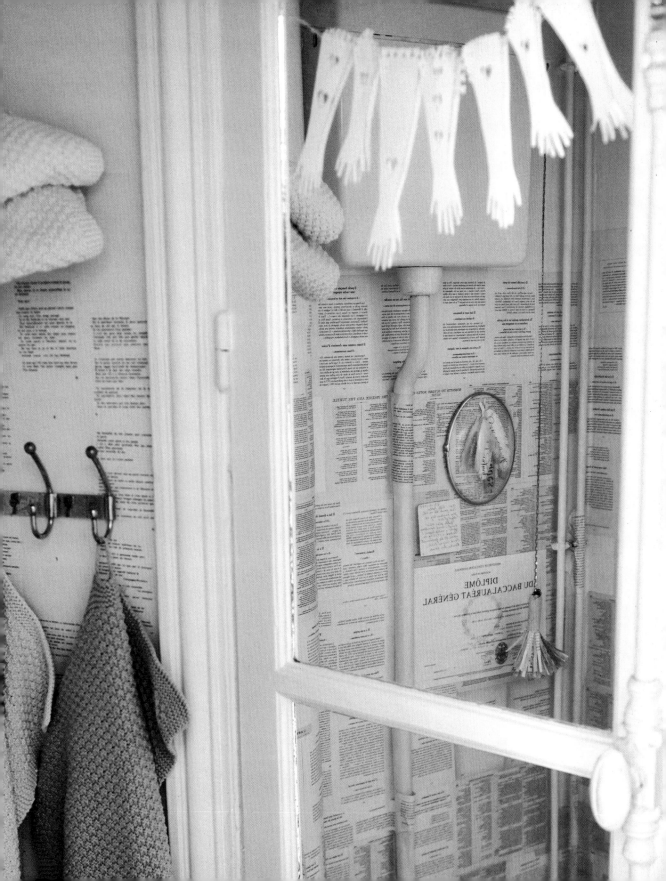

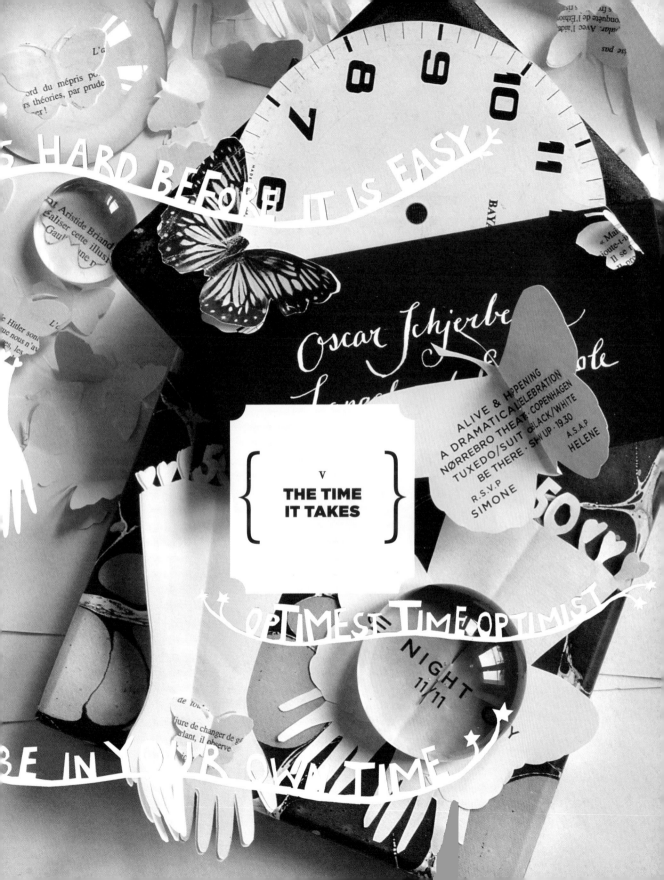

{ v
THE TIME
IT TAKES }

IT'S ABOUT TIME

Everything takes time, but too often these days we try to do things too quickly and rush through life without giving anything the right amount of attention. So in this chapter, we have arranged some projects according to how long they will take. This means you can set aside the time to really enjoy the process.

One of the great pleasures about taking our time is that we allow ourselves to disappear into our own thoughts and creativity, where we get to travel for a moment with time, staying with it and letting it all happen.

DO NOT WORRY ABOUT SOMETHING YOU CANNOT CONTROL.

SHIFT YOUR ENERGY INTO ALL YOU CAN CREATE.

EMBRACING YOUR MISTAKES

When you find yourself with a pencil in your hand, you may notice that you start scribbling or doodling on any piece of paper, just out of habit. Once you discover the joy of papercutting, you'll find the same thing happens when you have a pair of scissors in your hand. You don't need to show anyone the end result.

You could even gain immense satisfaction cutting up a disappointing rejection letter before it goes in the bin!

L♥VE

10 MINUTES
- -✄-

IF THE PROJECTS IN THIS CHAPTER WERE A WHOLE MEAL, THESE EXERCISES WOULD BE THE STARTER. THEY ARE EASY TO DIGEST AND WILL HOPEFULLY GIVE YOU PLENTY OF 'APPETITE' OR CONFIDENCE TO MAKE YOU CONTINUE ON TO THE FIRST AND MAIN COURSE.

SCISSOR HAPPY

The hands are ideal to use as gift tags, or a small bookmark – write a message on them and they are a great add-on to any present. The swallows can be used to decorate everything from your desk to your doorway.

YOU WILL NEED:
- **SCISSORS**
- **TRACING PAPER**
- **BLACK AND WHITE PAPER**

⤙ Trace these hands or the swallows and place the tracing paper on top of another piece of paper, then cut through both layers. Once you have got the hang of the shape, try cutting without a template – it may be easier than you think. if you want to, you can add a bit of pink paper to the swallow's chest or cut out a clover for them to hold.

AMORE

fatto a mano

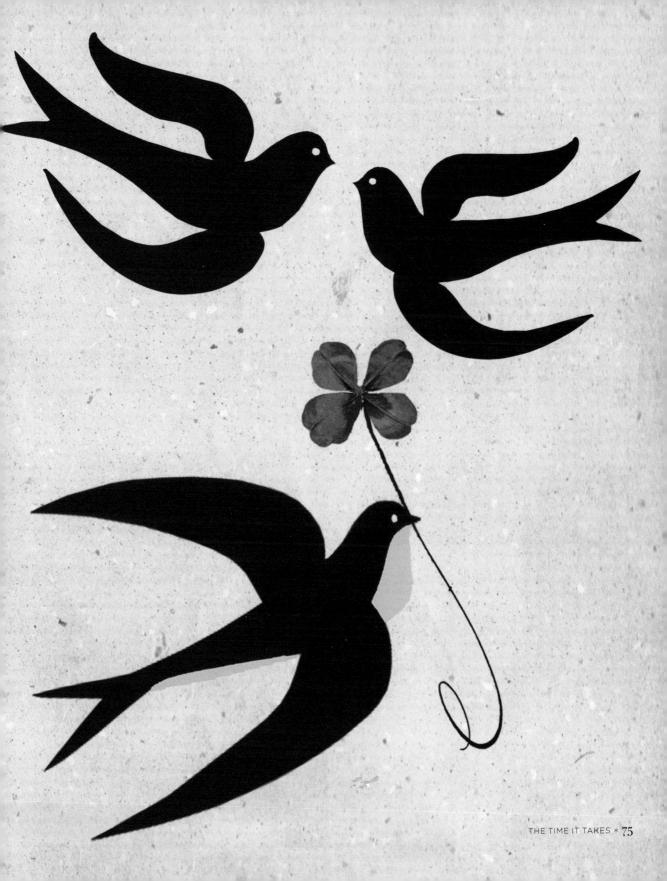

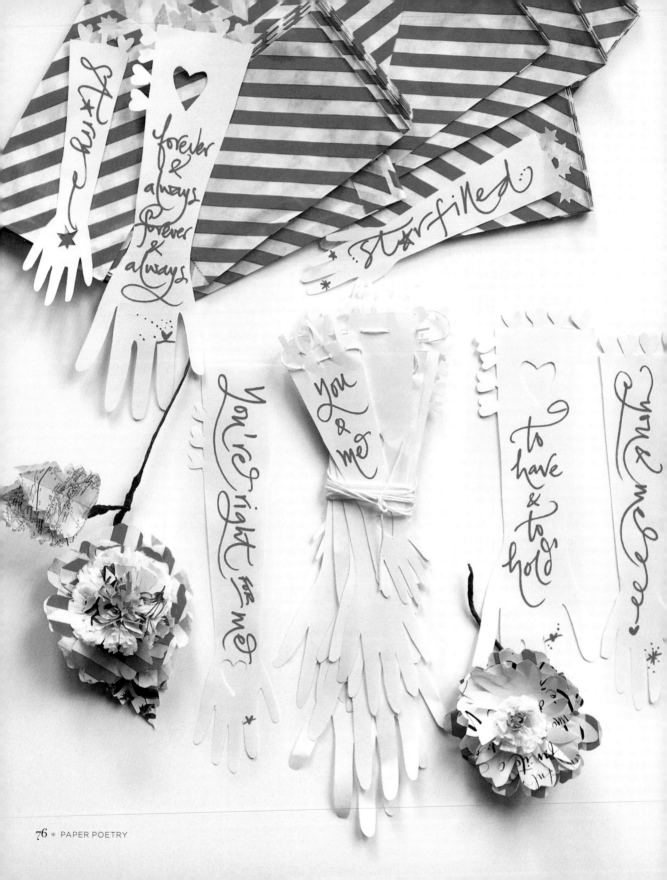

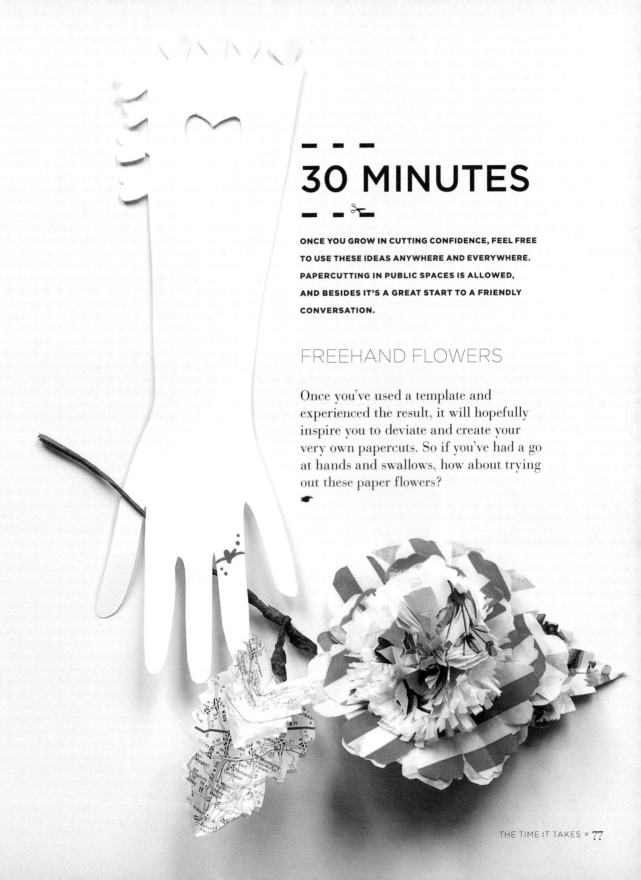

30 MINUTES

ONCE YOU GROW IN CUTTING CONFIDENCE, FEEL FREE TO USE THESE IDEAS ANYWHERE AND EVERYWHERE. PAPERCUTTING IN PUBLIC SPACES IS ALLOWED, AND BESIDES IT'S A GREAT START TO A FRIENDLY CONVERSATION.

FREEHAND FLOWERS

Once you've used a template and experienced the result, it will hopefully inspire you to deviate and create your very own papercuts. So if you've had a go at hands and swallows, how about trying out these paper flowers?

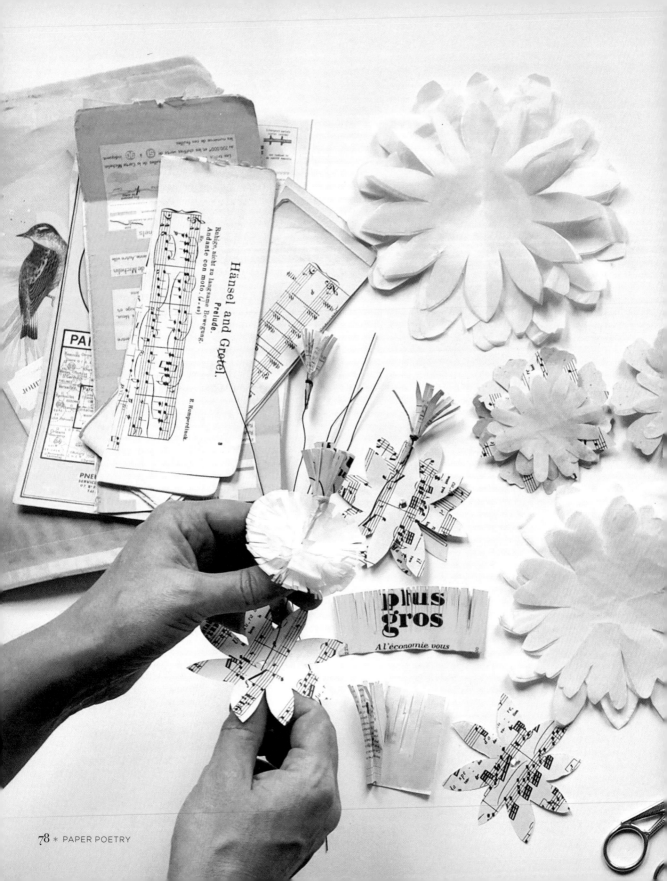

YOU WILL NEED:

- SCISSORS
- A VARIETY OF PAPER
- THIN WIRE
- MASKING TAPE AND GREEN FLORAL TAPE

Start by making the stigma – we used an old map. Cut out a strip of about 6 x 4cm, snip into it and then roll it and wrap wire around it (see page 32).

Cut different-sized circles with a petal edging, in different coloured paper. Layer the petals, biggest first and gradually getting smaller. Pierce a hole in the middle with the scissors and feed the wired stigma through it.

Use a bit of masking tape to attach the outer petal to where the wire was put through. Finally, wrap the floral tape around the wire.

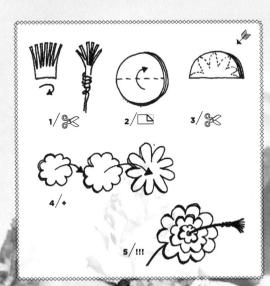

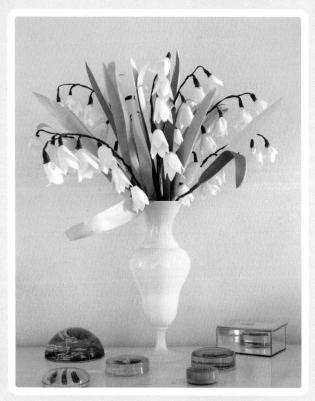

GROWING WONDERS

These beautiful lilies are made of white crepe paper, cut to shape and individually rolled into blossoming bells to create a long-lasting bouquet of pure happiness.

YOU WILL NEED:

- **SCISSORS**
- **CREPE PAPER IN DIFFERENT SHADES OF CREAM AND WHITE**
- **THIN WIRE**
- **GREEN FLORAL TAPE**
- **GREEN PAPER**

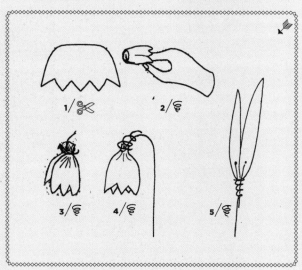

Cut the crepe paper in the shape of the petal template, then roll it, using a finger to roll the paper around into the shape of a bell, twist the paper at the top and wrap a piece of wire around it to give it a stem. Make 5–6 bells before you attach them all to one long piece of wire, one after the other. Wrap floral tape around the wire. Cut leaves out of green paper and attach them to the wire, then once again cover the wire with the floral tape.

Keep on going until you have a whole bouquet.

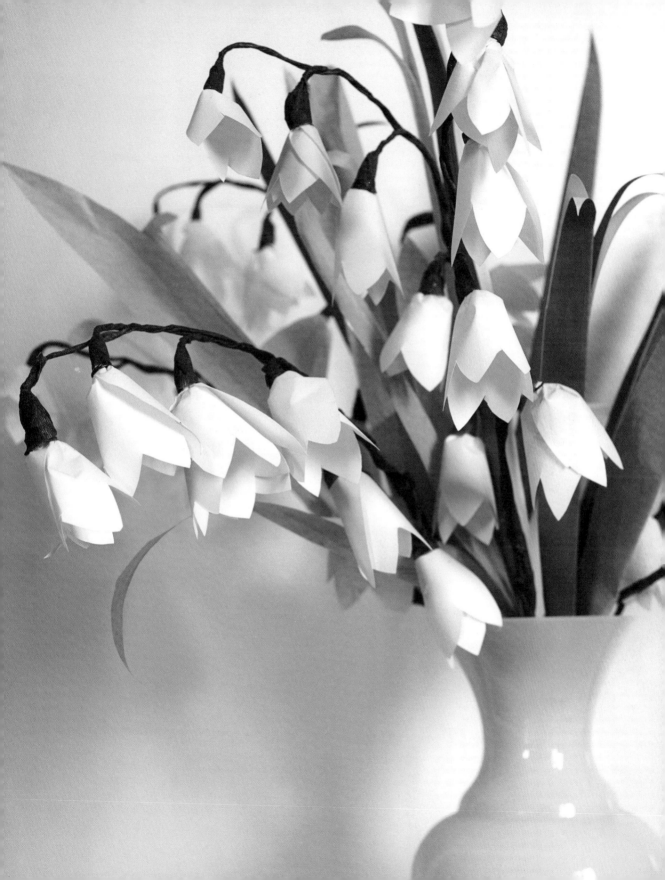

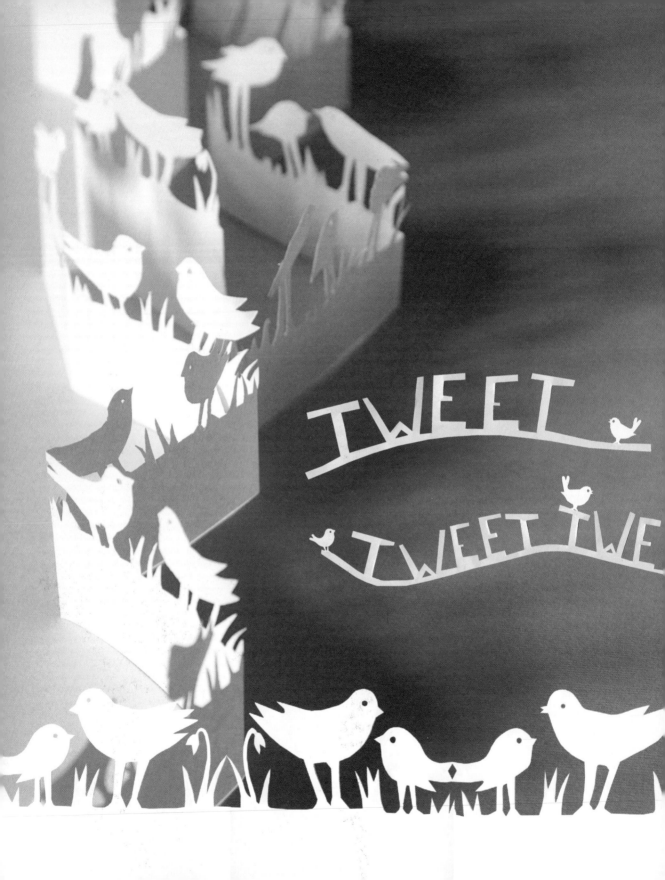

TWEET TWEET

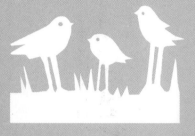

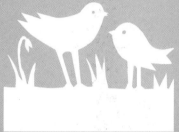

FOLD-OUT BIRDS

Folding the paper into a concertina gives you a long line of sweet little birds.

YOU WILL NEED:

- A 50CM STRIP OF PLAIN PAPER, NO THICKER THAN 80GSM
- SCISSORS

You should easily be able to fold the paper, so you can cut several layers at the same time. Fold the paper into 8cm sections, pleated into a concertina.

Trace and cut out your chosen template, then place it on top of the folded paper. Cut around the template, cutting through all the layers. Remember to move the paper so that your scissors stay stable and you are in a comfortable position. The scissors are your tool – you are in control – so only snip when you are ready. When you're finished, unfold the concertina to see the result.

Once you grow in confidence, you can create your own templates, or even try some simple shapes freehand.

[*Go to our YouTube page, Paper Poetry, and watch 'Helene and Simone's Easter Paper Parade'.*]

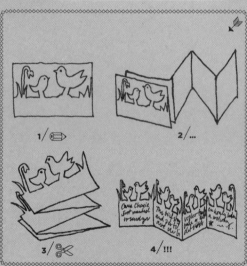

1/ ✏️ 2/... 3/ ✂️ 4/ !!!

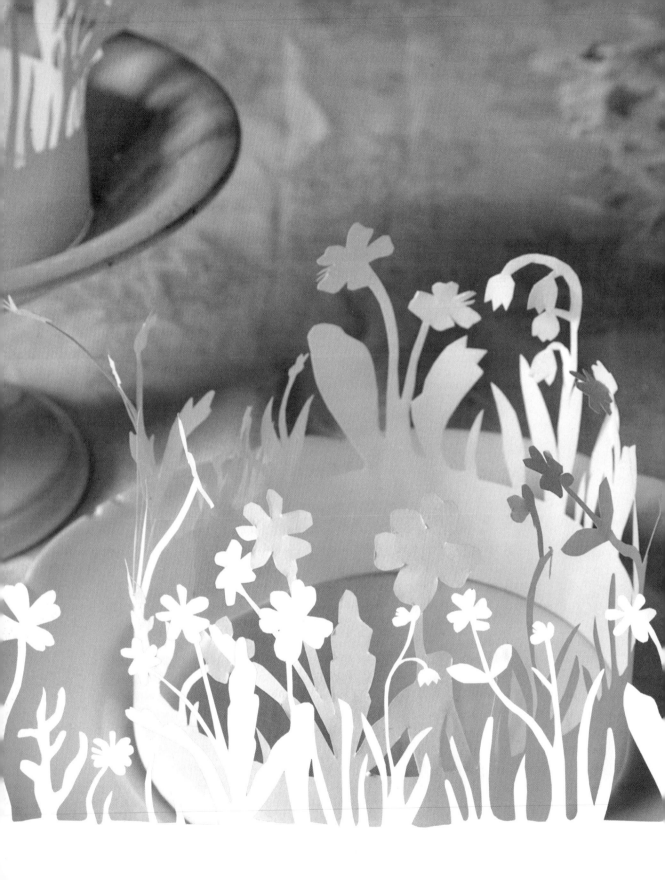

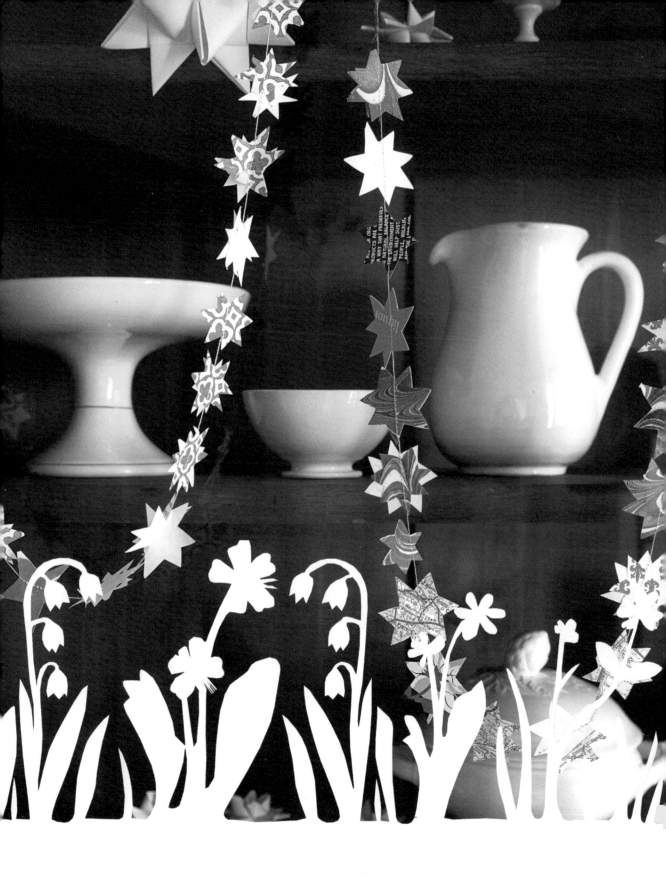

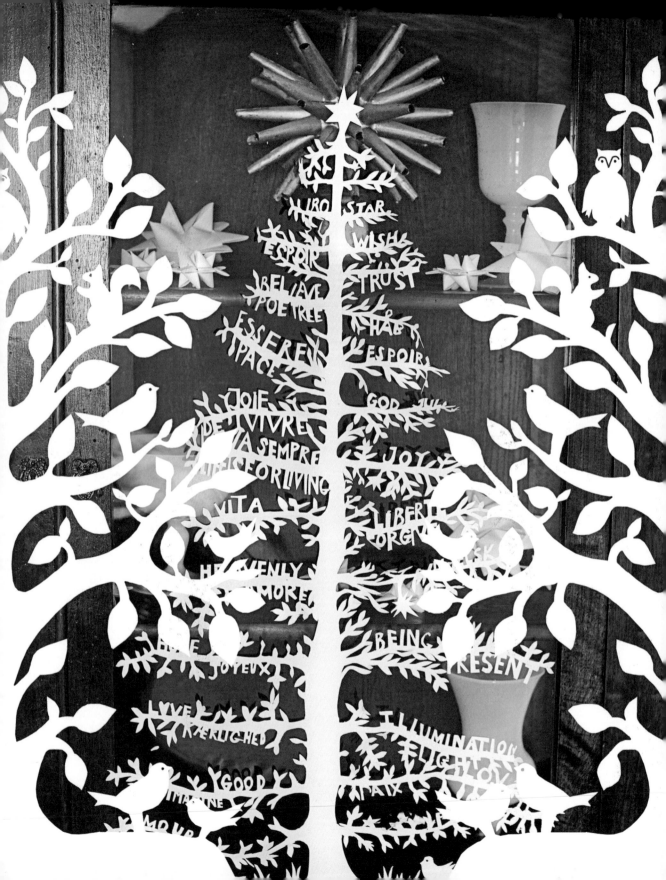

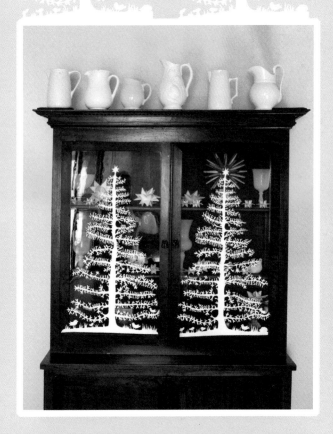

2 HOURS

Treat yourself to spend some more time cutting up a poetree.

POETREES

Start with a simpler tree for practice.

✎ **Trace one of the tree halves on either side of the image on the left and use it as a template. Fold a piece of paper in half and put the tracing on top of this, with the straight edge on the fold. Cut through the tracing paper and your piece of paper. Unfold, and you will have a whole tree.**

And now for the wordy poetree. This one will take more practice, but once you feel ready, branch out and give yourself some poetic licence.

✎ **Add some words to the template as if they are growing out of the branches. Each letter will need to stay 'rooted' to the branch it sits on, or hangs from.**

A WEEKEND

MORE TIME-CONSUMING PROJECTS FOR WHEN YOU REALLY WANT TO GET YOUR SCISSORS INTO SOMETHING.

BUTTERFLY CURTAIN

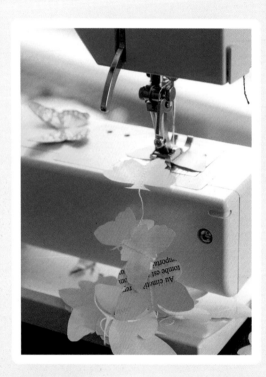

This butterfly curtain creates incredible shades of light and dark, and makes a beautiful sound in a gentle breeze. Of course, these curtains can't be washed but they are certainly worth spending a weekend on. The first ones we made are almost five years old now and they still look amazing.

YOU WILL NEED:

- **SCISSORS**
- **HUNDREDS OF CUT-OUT BUTTERFLIES IN WHATEVER PAPER YOU FANCY**
- **A PIECE OF SOFT, TRANSPARENT FABRIC ABOUT 10CM WIDER AND LONGER THAN THE WINDOW TO ALLOW FOR HEMS**
- **SEWING MACHINE**

Cut out hundreds of butterflies, as described on page 23. 'Feed' the butterflies into the sewing machine (there's no need to pin them, just place) and sew them one at a time onto the fabric in vertical lines. This is time-consuming, but not difficult – and it's so rewarding! Don't worry about 'mistakes' – the overall beauty of your curtain will take your breath away.

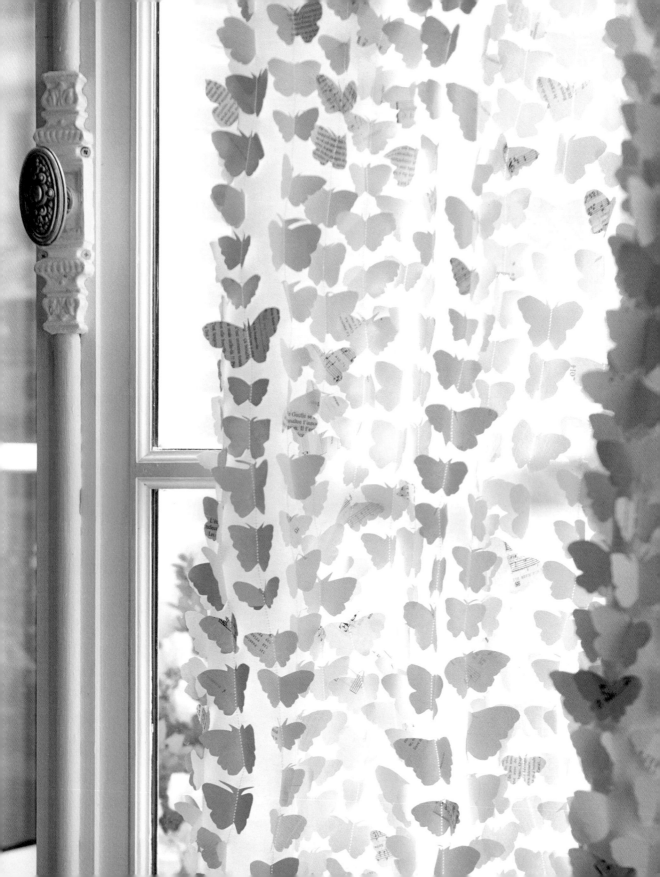

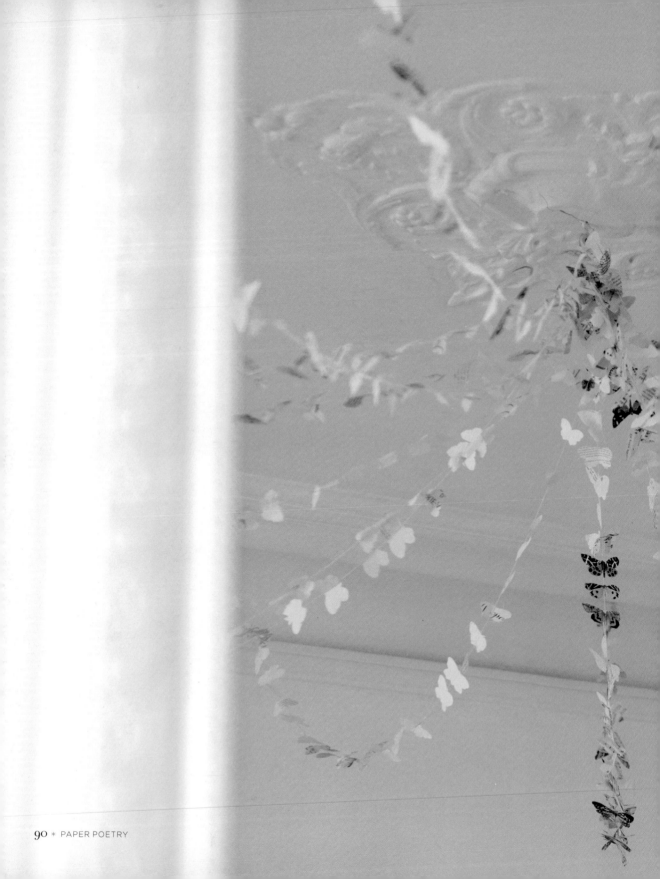

BUTTERFLY HEAVEN

Instead of 'counting sheep' we hung up garlands of butterflies from the bedroom ceiling. The shadows double the numbers, so before you've finished counting you will probably be sound asleep.

YOU WILL NEED:

- **SCISSORS**
- **HUNDREDS OF CUT-OUT BUTTERFLIES IN WHATEVER PAPER YOU FANCY**
- **SEWING MACHINE**

Cut out hundreds of butterflies, as described on page 23. 'Feed' the butterflies into the sewing machine (there's no need to pin them, just place), sewing them together until you have a 3-metre long line of butterflies.

Attach each garland to the ceiling using sticky tack, stretching them from the corners of the ceiling to the centre.

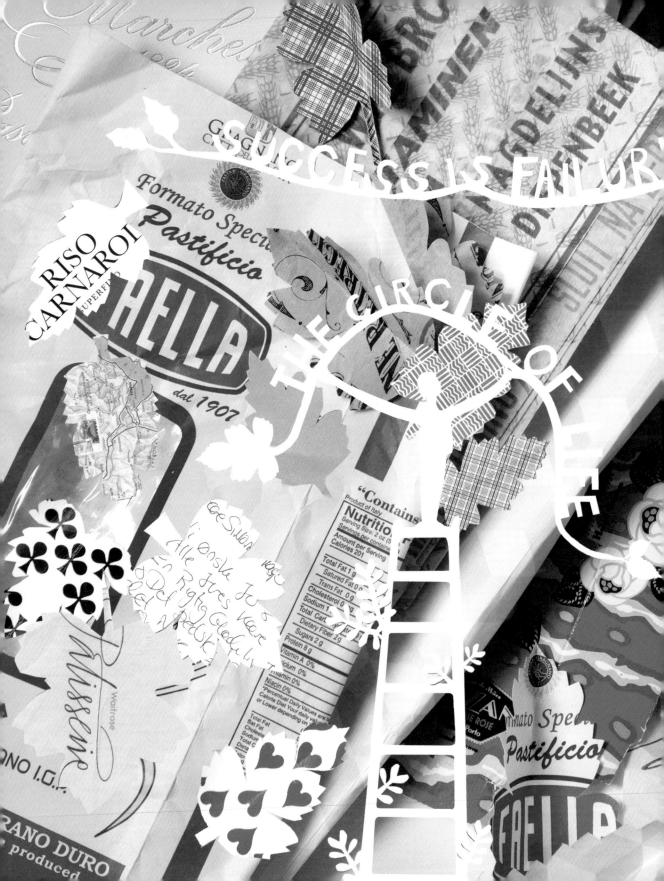

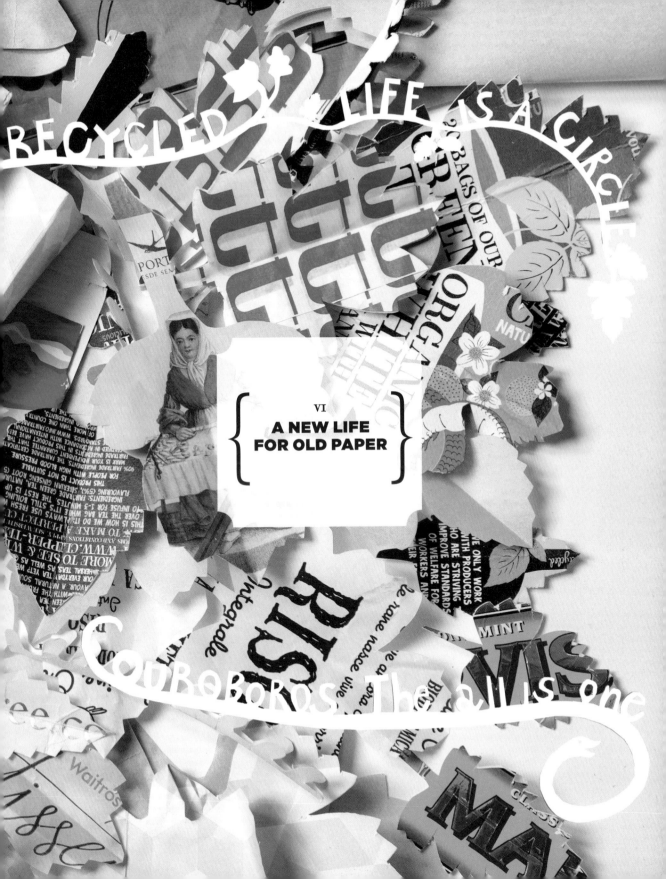

RECYCLED · LIFE IS A CIRCLE

VI
**A NEW LIFE
FOR OLD PAPER**

OUROBOROS: The all is one

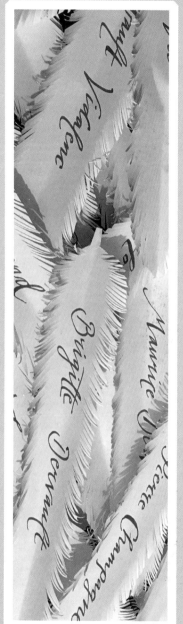

A NEW LIFE
FOR OLD PAPER

In this era of technology, all has become more and more 'paperless'. Paper is, however, still everywhere. One of the places it seems to be used more than ever is in the increasingly elaborate packaging that manufacturers and retailers use to tempt us into buying things. So why not reuse this packaging and give it a new lease of life through your papercutting? Recycle a sales catalogue into a wreath, turn old wrapping paper into a feather garland, or transform a paper bag into a lantern.

[To see us creating feathers, visit our YouTube page, Paper Poetry, and watch our video 'Helene and Simone's Feather Making'.]

'HOPE IS THE THING WITH FEATHERS
THAT PERCHES IN THE SOUL
AND SINGS THE TUNE WITHOUT THE WORDS
AND NEVER STOPS AT ALL'
EMILY DICKINSON, POET (1830–1886)

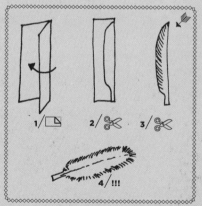

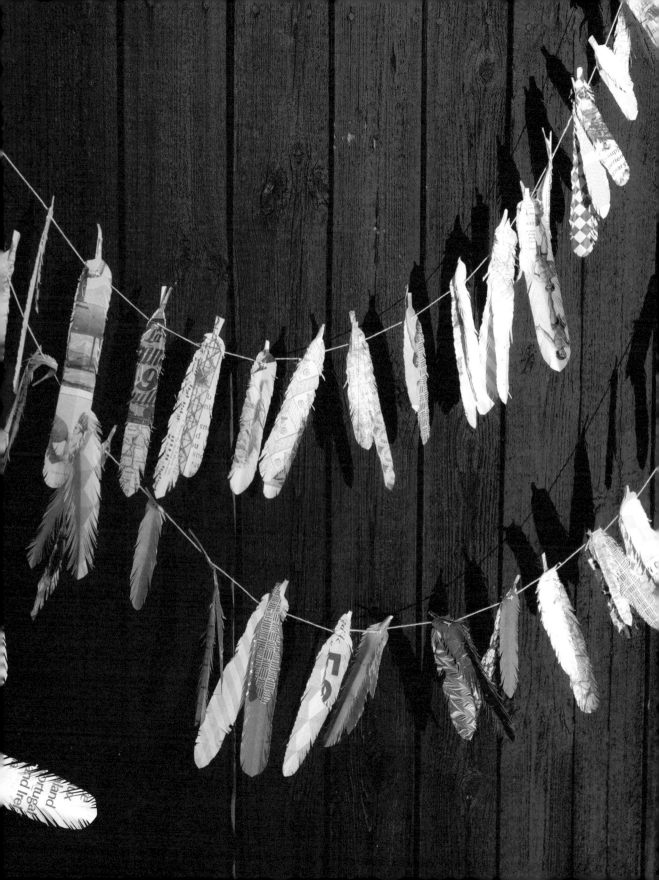

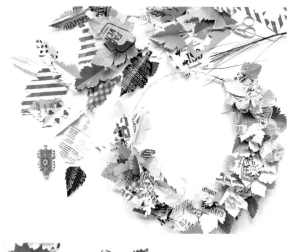

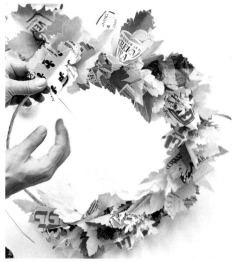

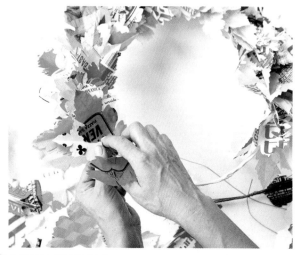

RECYCLED WREATH

A circle of recycled life. Vary the colours to suit your decor, whether you want a festive Christmas wreath or a colourful spring one.

YOU WILL NEED:

- **WIRE (THICK AND THIN)**
- **WHITE MASKING TAPE**
- **SCISSORS**
- **SOME RECYCLED PACKAGING PAPER**
- **RECYCLED STRING OR TWINE**

Shape the thicker wire into a circle 25cm in diameter. Cover it with white masking tape.

Cut out dozens of leaves from all sorts of recycled packaging paper. Use the thinner wire to bind the leaves, one or two at a time or even in small bundles, to the wire circle. Once the circle is covered in leaves, you can add some recycled string or twine as a bow.

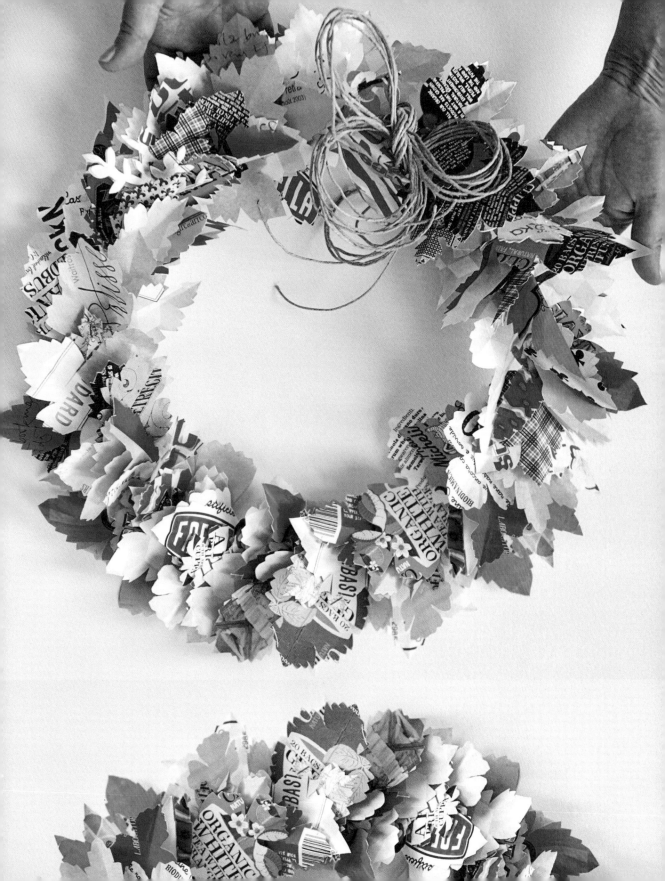

CHRISTMAS HEARTS

In our native Denmark, Christmas is often called the feast of hearts, and woven Christmas heart decorations are a common sight. The woven heart dates back to Hans Christian Andersen's time (some even credit him with inventing it) and now it is a traditional 'must' on every Christmas tree in Denmark.

YOU WILL NEED:

* **SCISSORS**
* **RECYCLED PAPER IN TWO DIFFERENT COLOURS**

Fold 2 different-coloured pieces of paper in half and cut out the half-oval shape shown in the photos on the left. Make sure you have 2 identical parts, both with a fold at the bottom. Cut 'fringes' from the fold, stopping a few centimetres from where the semi-circle starts. Weave the fringes into one another, making sure that every fringe, every time, goes under, then over the other fringe, alternating all the time, so you need to weave from both sides in order to turn your heart into a 'basket'.

It might seem complicated at first, but once you've made one or seen someone else do it, it's easy – so we've made a film to help you.

[*Go to our YouTube page, Paper Poetry, and watch 'Helene and Simone's Heart Making'.*]

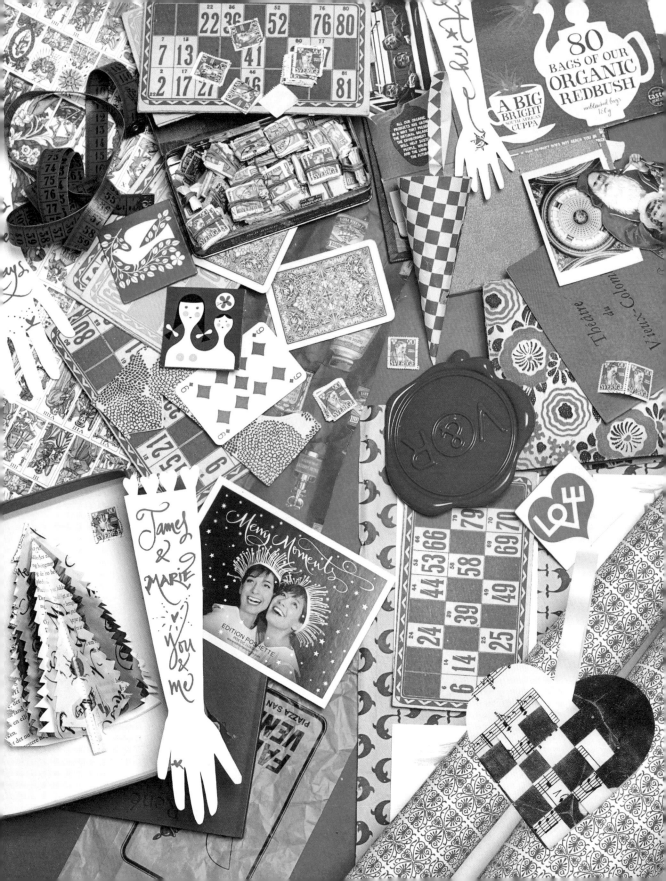

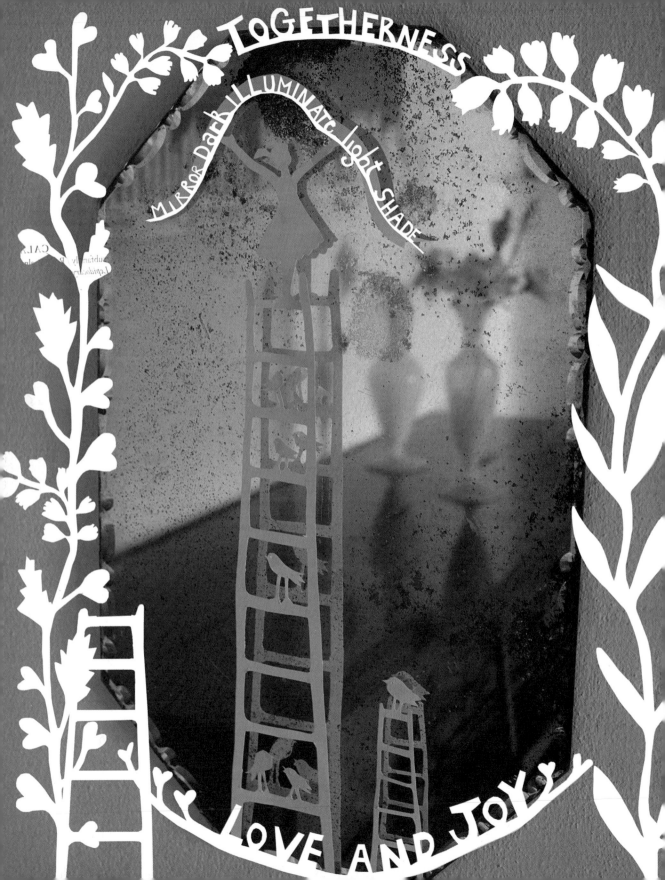

All the Variety

all the Charm

all the Beauty of Life

{ VII

**LIGHT
AND
SHADOW** }

is Made Up of

LIGHT AND Shadow

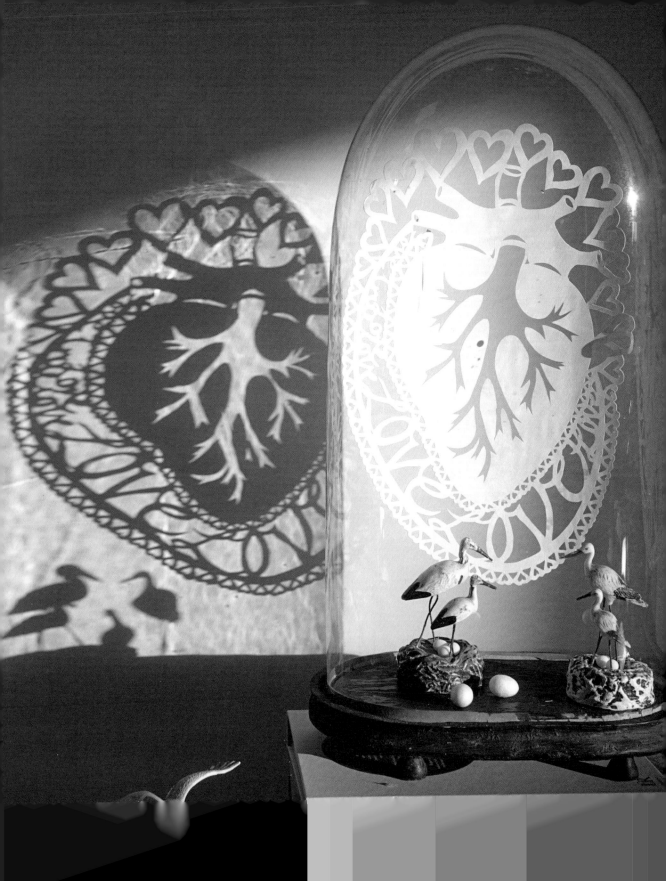

LIGHT AND SHADOW

Sometimes papercuts are at their best when their shadows appear on the wall behind them. It makes them even more interesting, not just because they 'double up' the artwork but often there is another story told through the shadow. The imperfections are entirely erased in the shadow and it can give a different mood. So, if you are looking for a special place to place a papercut, for example in a bell jar, think about how it will cast its shadow.

THE PLAY BETWEEN LIGHT AND DARK IS SO EVIDENT IN PAPERCUTTING AND IT REALLY IS A GAME, WHERE BOTH 'PLAYERS' NEED TO WORK ALONGSIDE EACH OTHER.

← Heart cut-out in paper by David S. under a bell jar. Notice how the shadow enhances the many 'loves'.

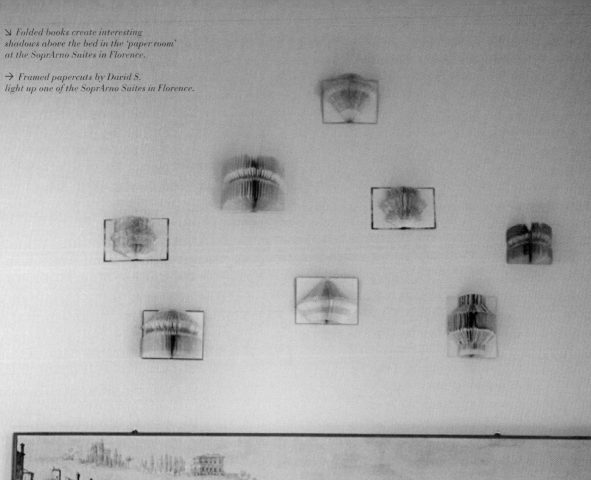

↘ *Folded books create interesting shadows above the bed in the 'paper room' at the SoprArno Suites in Florence.*

→ *Framed papercuts by David S. light up one of the SoprArno Suites in Florence.*

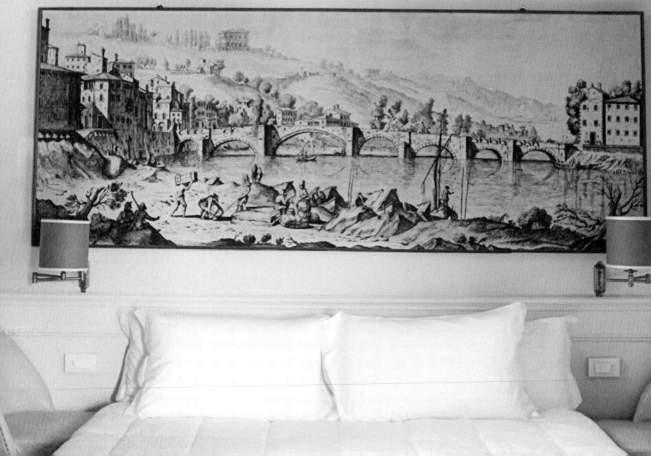

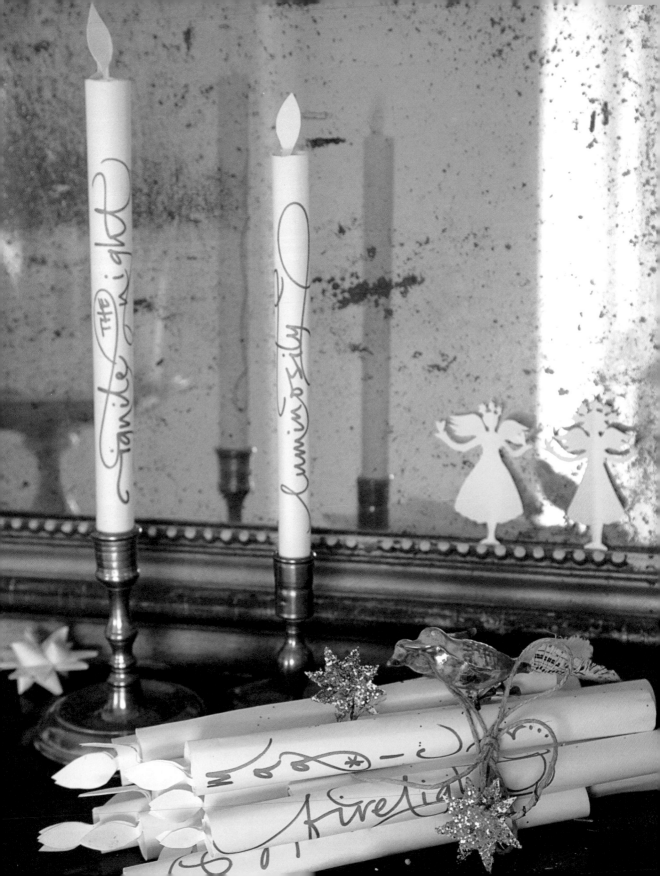

PAPER CANDLES

One could say we were playing a trick on our imagination by creating a candle in paper. Of course, these aren't for burning, but they can still 'light up' the dinner table.

🪶 **Roll plain paper into a tube and glue it so that it stays in place. Cut the top into the shape of a flame, then pop it into a candlestick.**

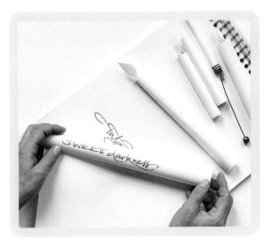

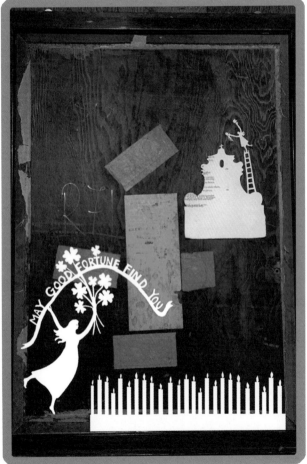

↑ *Rolling a candle.*

↗ *The back side of a frame with a papercut on it at the SoprArno Suites in Florence.*

{
VIII

**PAPER FOR
ALL SEASONS**
}

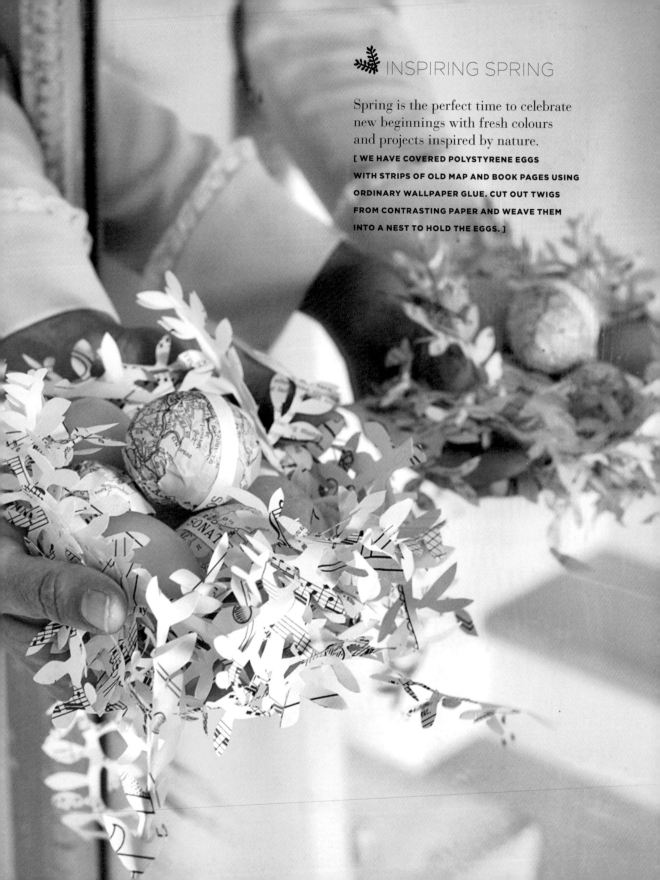

INSPIRING SPRING

Spring is the perfect time to celebrate new beginnings with fresh colours and projects inspired by nature.

[WE HAVE COVERED POLYSTYRENE EGGS WITH STRIPS OF OLD MAP AND BOOK PAGES USING ORDINARY WALLPAPER GLUE. CUT OUT TWIGS FROM CONTRASTING PAPER AND WEAVE THEM INTO A NEST TO HOLD THE EGGS.]

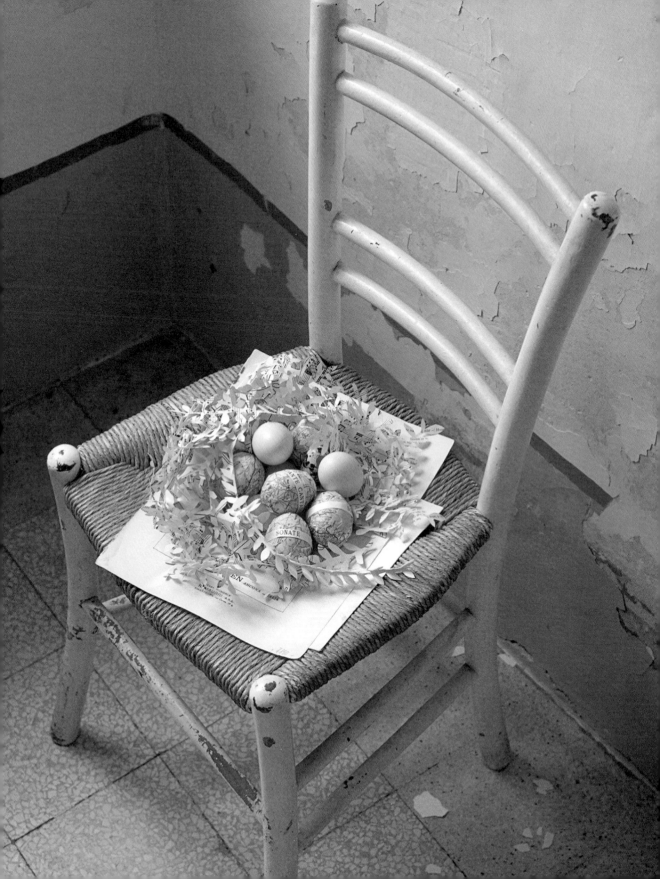

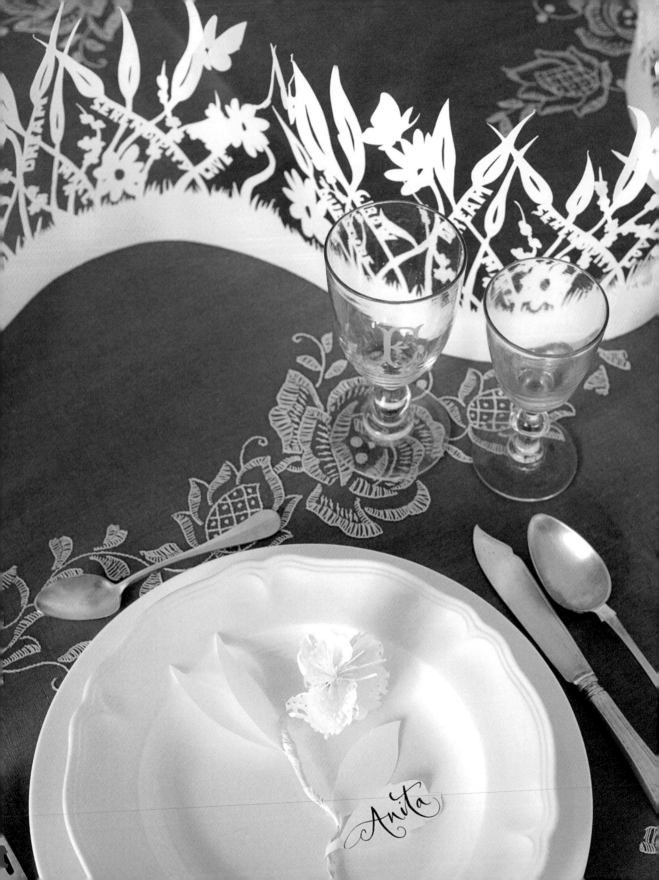

 A SPRING TABLE

Adorn your table with hop-along bunnies.

[TO MAKE THE BUNNIES, FOLLOW THE FOLD-OUT
BIRDS INSTRUCTIONS ON PAGE 83, BUT DRAW YOUR
OWN BUNNY TEMPLATE OR USE THE ONES BELOW
AS A GUIDELINE.]

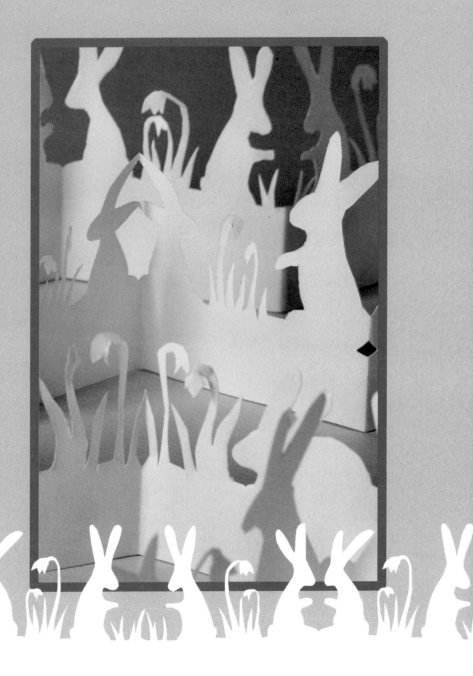

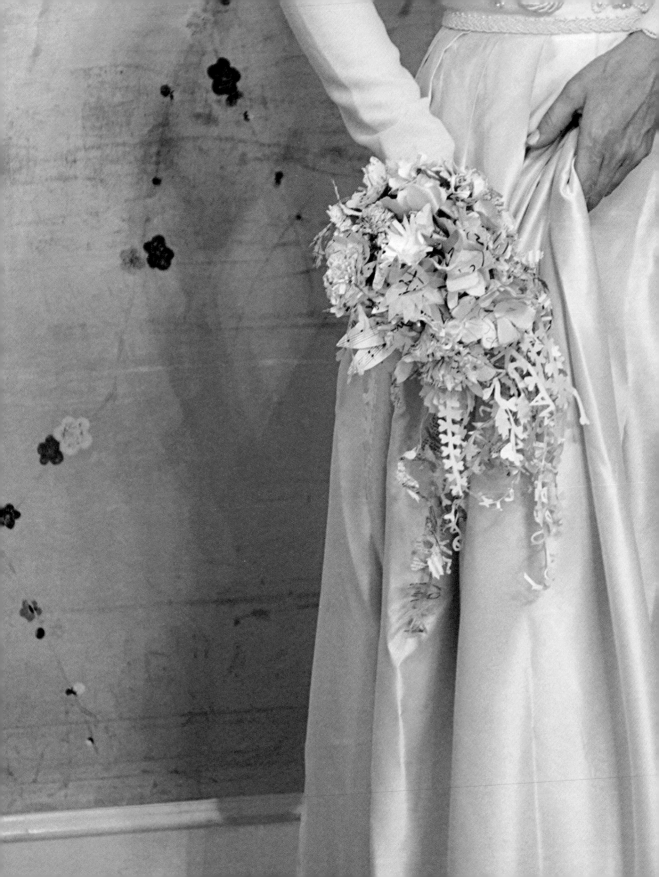

FOREVER YOURS

For a bridal bouquet, use something old,
something new, something borrowed,
something blue...as long as it's all paper.

[TO MAKE PAPER FLOWERS AND BOUQUETS,
SEE PAGES 34 AND 79.]

Anita

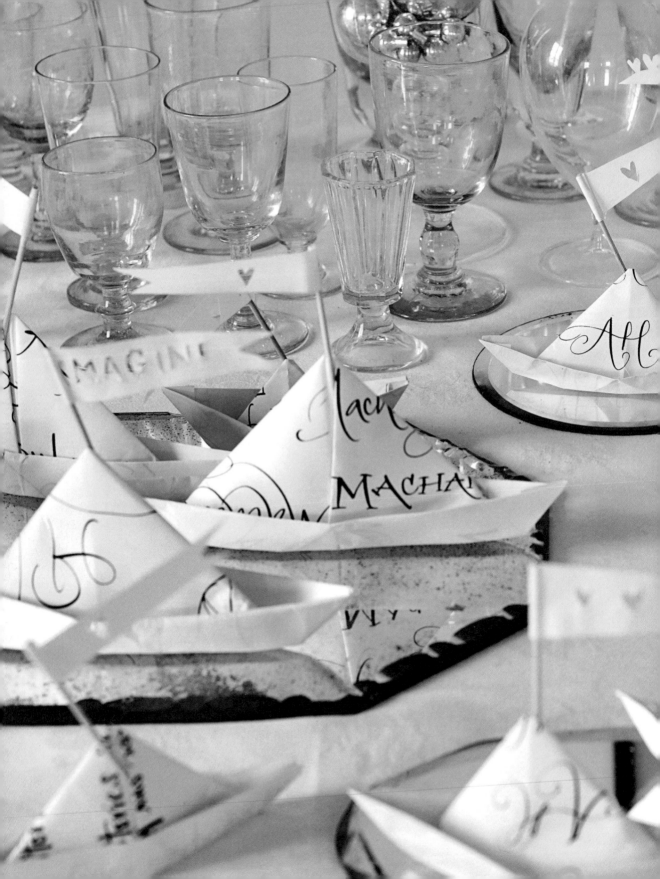

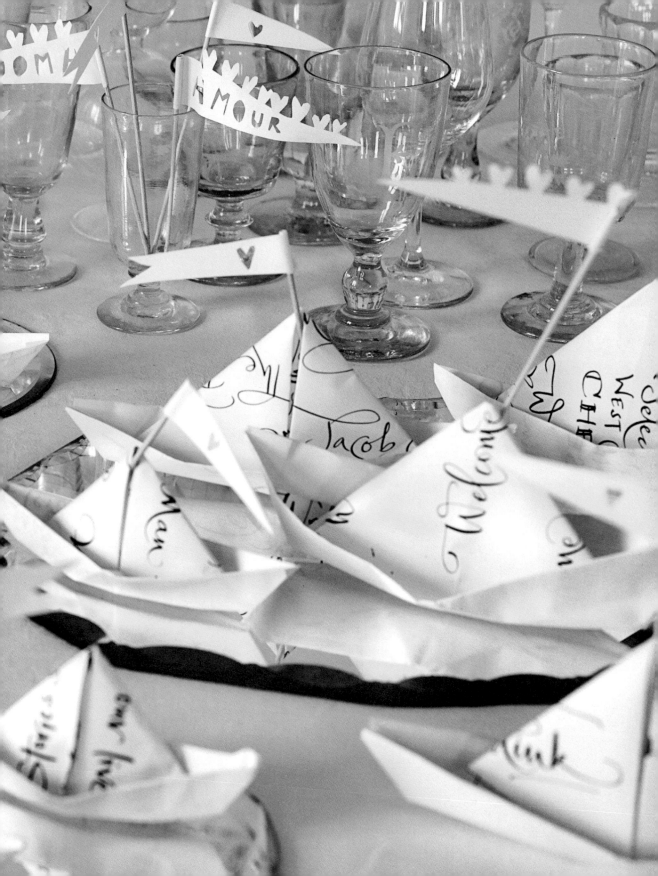

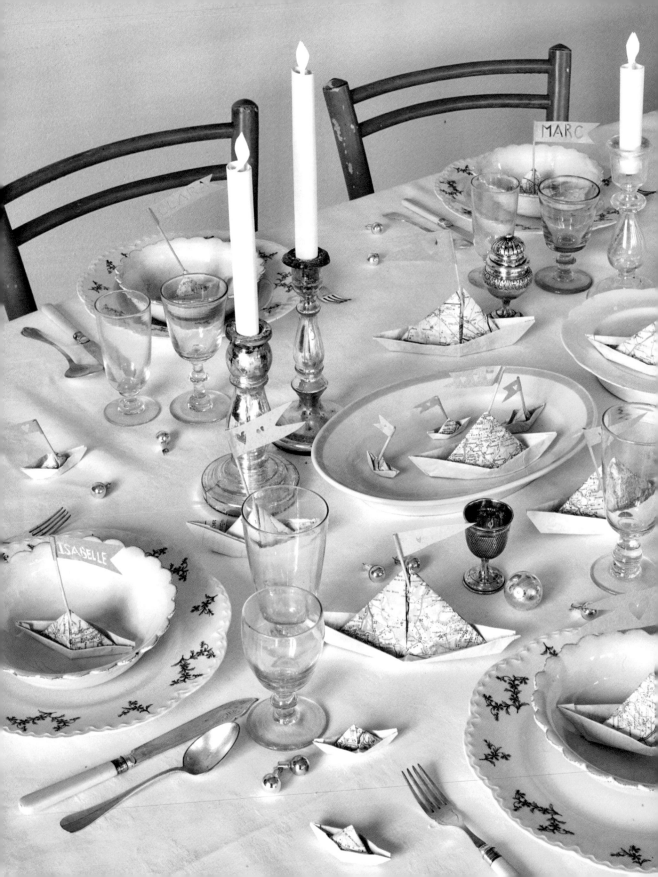

 ALL ABOARD

Simple paper boats made of maps make
perfect table decorations for a bridal banquet.

**For each boat, fold a piece of paper in half, with the
fold at the top. Fold the top corners down towards the
centre, stopping 2.5cm from the bottom of the paper. Fold
the bottom edges up and open out the paper boat.**

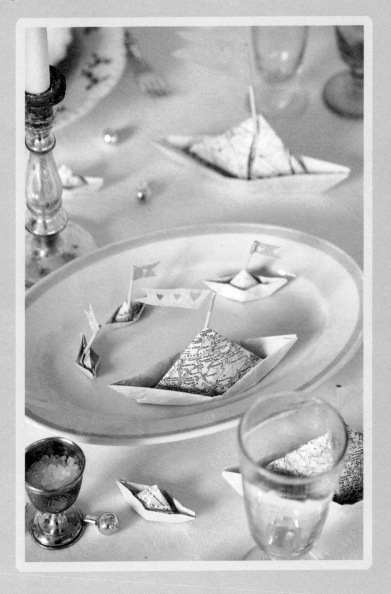

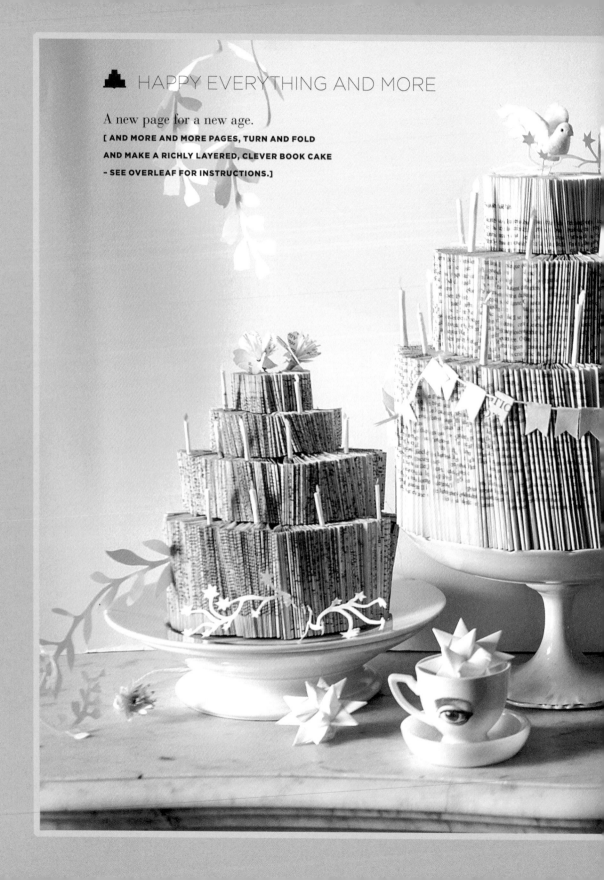

▲ HAPPY EVERYTHING AND MORE

A new page for a new age.

**[AND MORE AND MORE PAGES, TURN AND FOLD
AND MAKE A RICHLY LAYERED, CLEVER BOOK CAKE
– SEE OVERLEAF FOR INSTRUCTIONS.]**

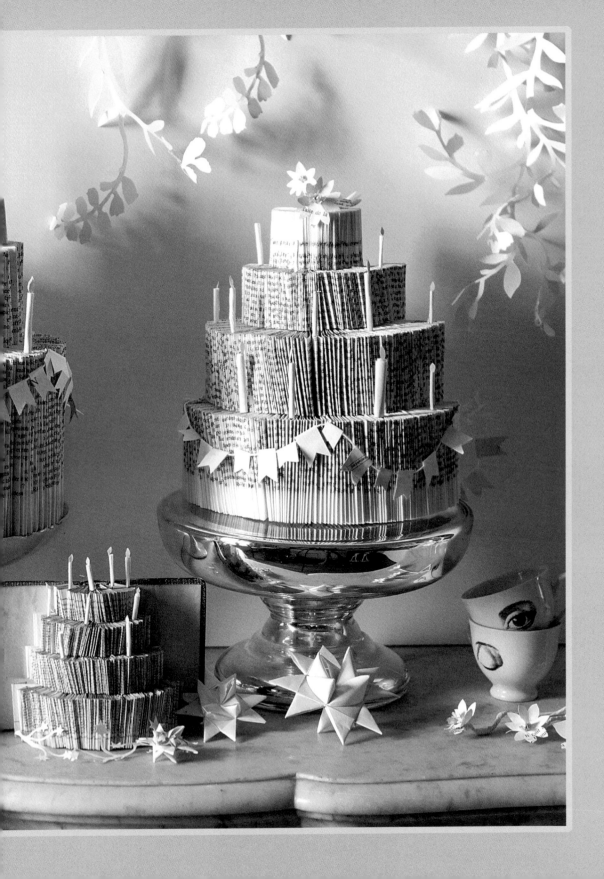

BIRTHDAY CAKES

Go gluten-free with a birthday cake made out of an old book. Have your cake and 'read' it. This will take at least a few hours to make but is in fact easier than it looks.

YOU WILL NEED:

- **SCISSORS (OR A CRAFT KNIFE IF YOU PREFER)**
- **AN OLD BOOK**

Depending on the size of the book, decide whether you want to make three or four cake layers. You can also choose whether to remove the cover, in which case you can make a completely round cake (you need a thicker book for this), or to leave it on so that it forms a back drop for the cake.

Create your own template on the first page of the book. For a cake with three layers, make two cuts into the page, to create three strips.

Then fold in the page to see how much you will need to cut off the top two strips so that the book will fold into three distinct layers. Each strip should only be folded once so that the thickness is the same.

Once you're satisfied with your layers, cut the rest of the book and fold each strip in towards the spine. When you have finished folding, you can clip or glue the pages into place if needed. See page 107 for how to make candles and page 63 for how to make bunting.

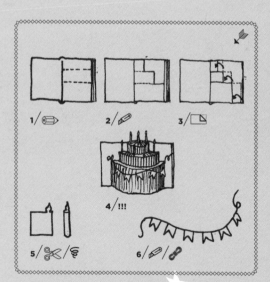

1/ ✏️ 2/ ✏️ 3/ 🗒️

4/ !!!

5/ ✂️ / 🧵 6/ ✏️ / 🔗

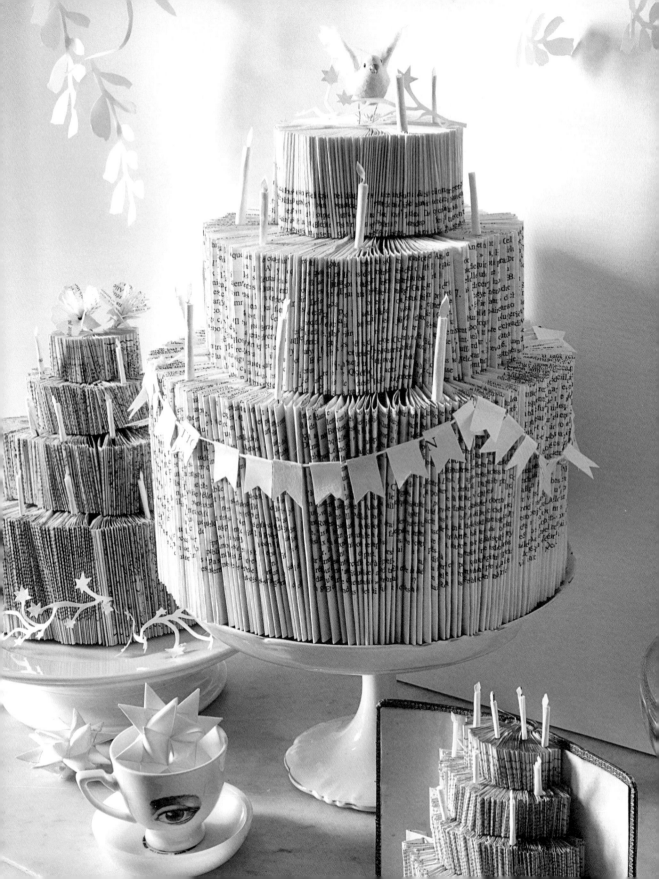

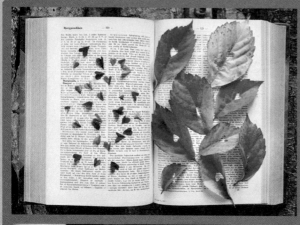

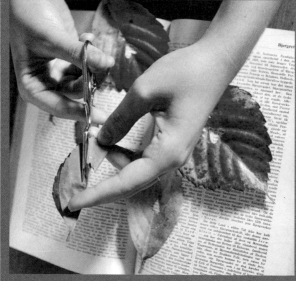

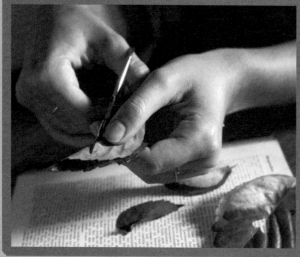

LOVE LEAVES

Ninety -five per cent of the raw material used to make paper comes from trees. One could almost say that the roots of paper are the tree, even though whenever we see a tree it's hard to imagine that something so delicate and refined as a piece of paper actually comes from something so sturdy, tall and strong.

The leaves from a tree are just as delicate as paper, so why not collect freshly fallen autumn leaves and cut them into decorations? They look beautiful when still fresh, and they last for a while afterwards as they dry.

Cutting into a leaf is an altogether different experience, but the effect is great, especially if you stay simple and small.

Collect fresh autumn leaves, fold them in half and cut a small heart into the centre.

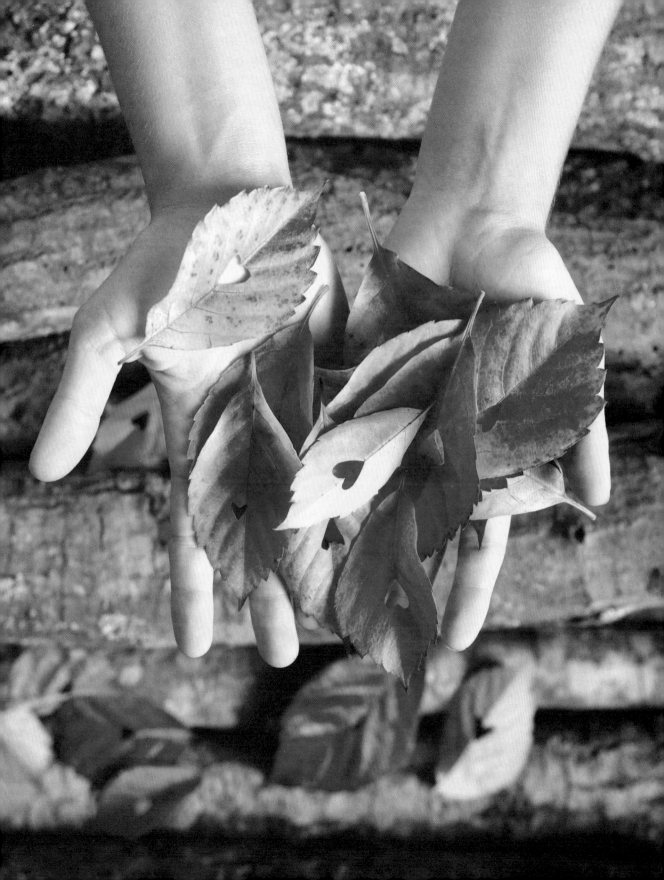

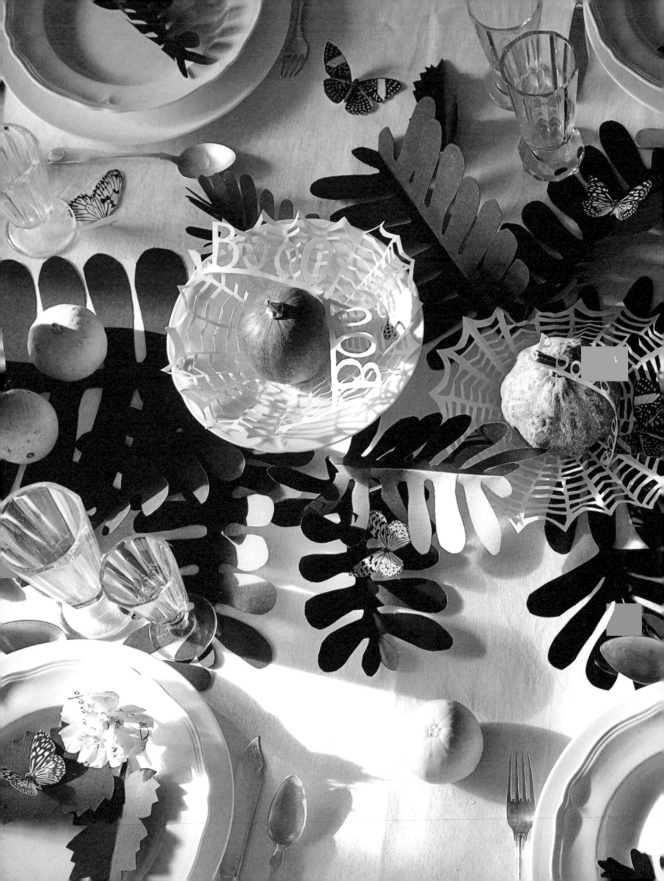

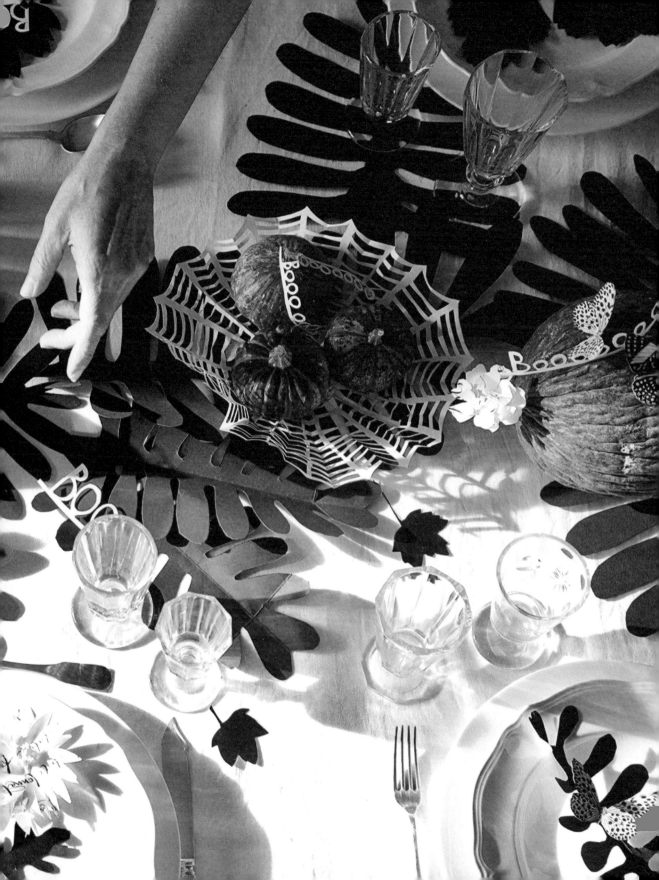

SOPHISTICATED SPOOKY HALLOWEEN

Simple papercuts in monochrome colours make for a supernatural tablesetting.

[CUT LARGE LEAVES OUT OF BLACK PAPER, AND ATTACH FLOWERS MADE FROM WHITE PAPER (SEE PAGES 34 AND 79). EXPERIMENT WITH FOLDING AND CUTTING PAPER TO MAKE SPIDERWEBS.]

[Go to our YouTube page, Paper Poetry, and watch 'Helene and Simone's Spooky Spiderwebs'.]

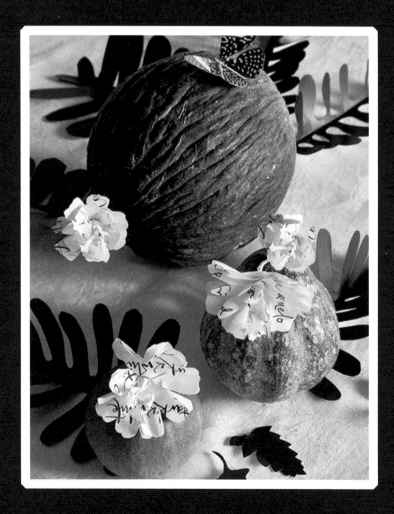

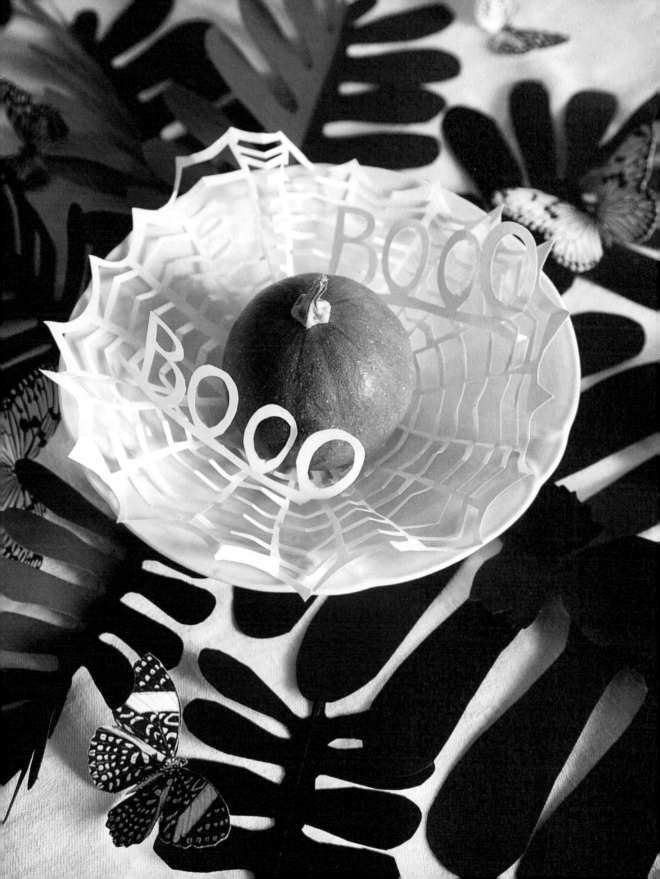

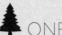 ONE, TWO, TREE!

Seasonal Christmas decorations, either hanging or standing, in white or coloured paper, create a Christmas forest – flat, folded, layered or even 'tree'- D.

[FOLLOW THE INSTRUCTIONS ON PAGE 63, BUT REPLACE THE HOT AIR BALLOON TEMPLATE WITH A CHRISTMAS TREE.]

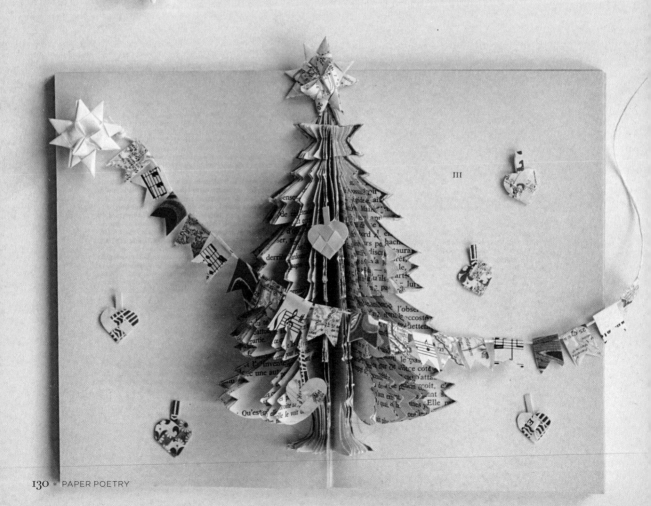

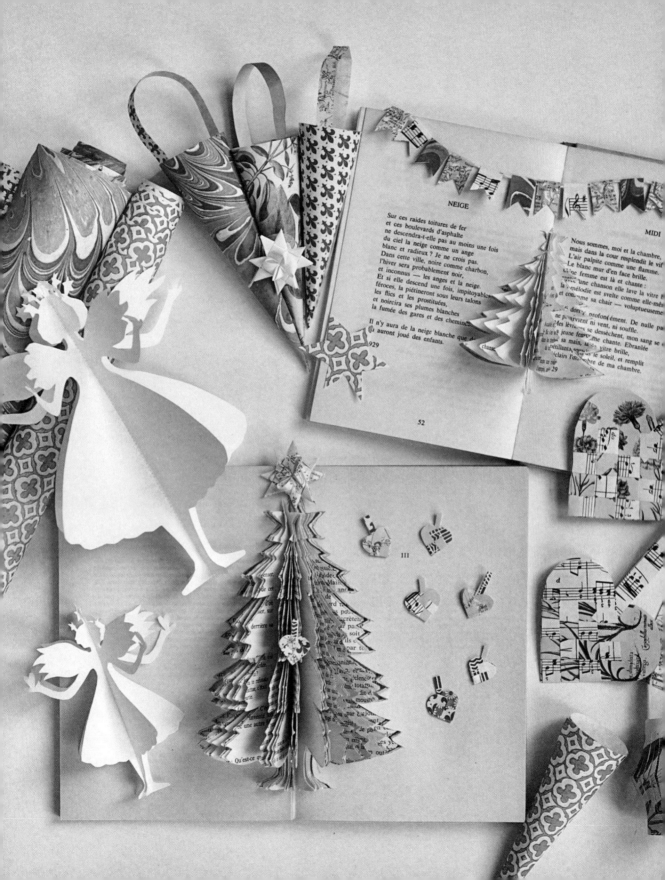

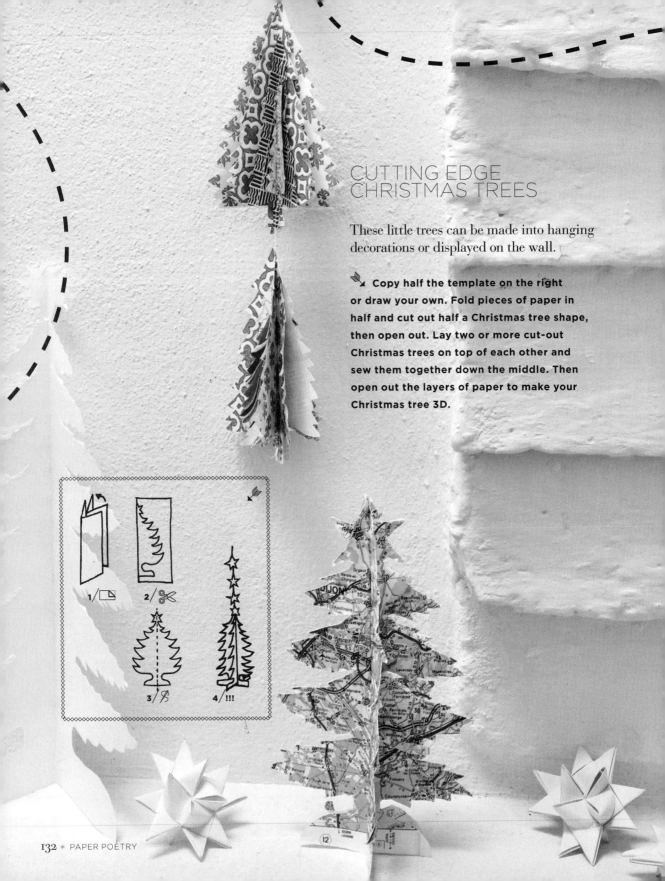

CUTTING EDGE
CHRISTMAS TREES

These little trees can be made into hanging
decorations or displayed on the wall.

Copy half the template on the right
or draw your own. Fold pieces of paper in
half and cut out half a Christmas tree shape,
then open out. Lay two or more cut-out
Christmas trees on top of each other and
sew them together down the middle. Then
open out the layers of paper to make your
Christmas tree 3D.

1/

2/

3/

4/ !!!

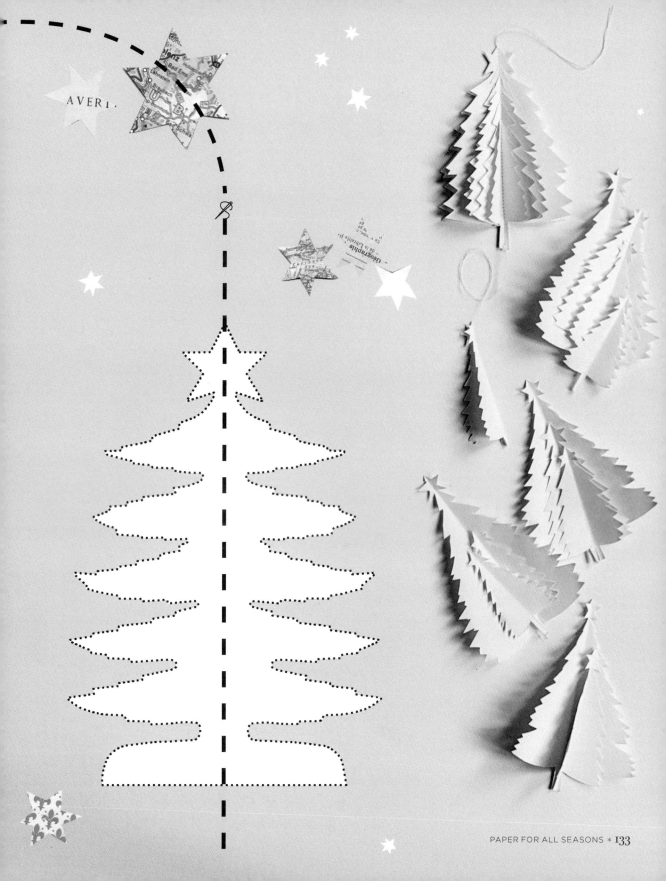

AVERT.

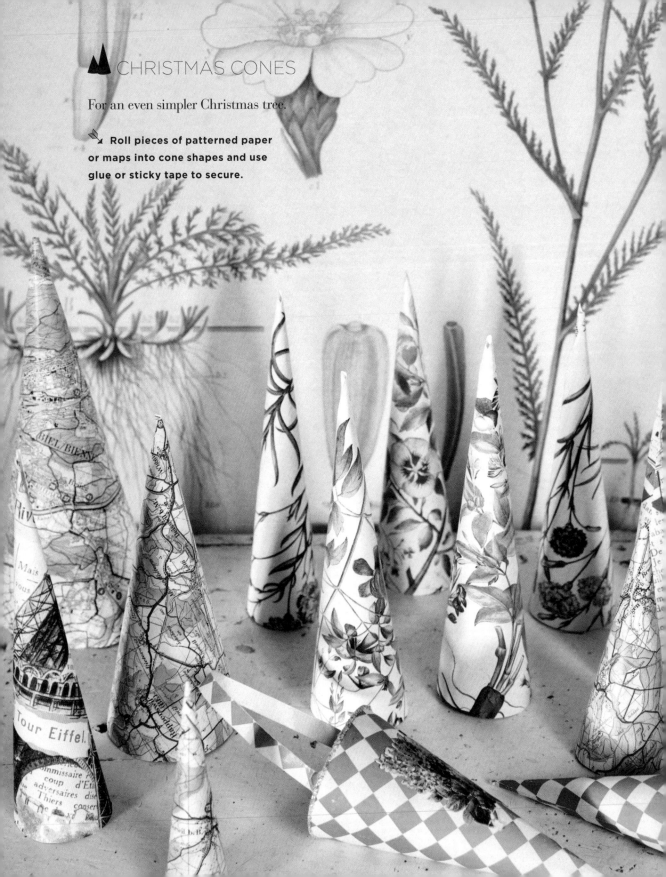

▲ CHRISTMAS CONES

For an even simpler Christmas tree.

➤ **Roll pieces of patterned paper or maps into cone shapes and use glue or sticky tape to secure.**

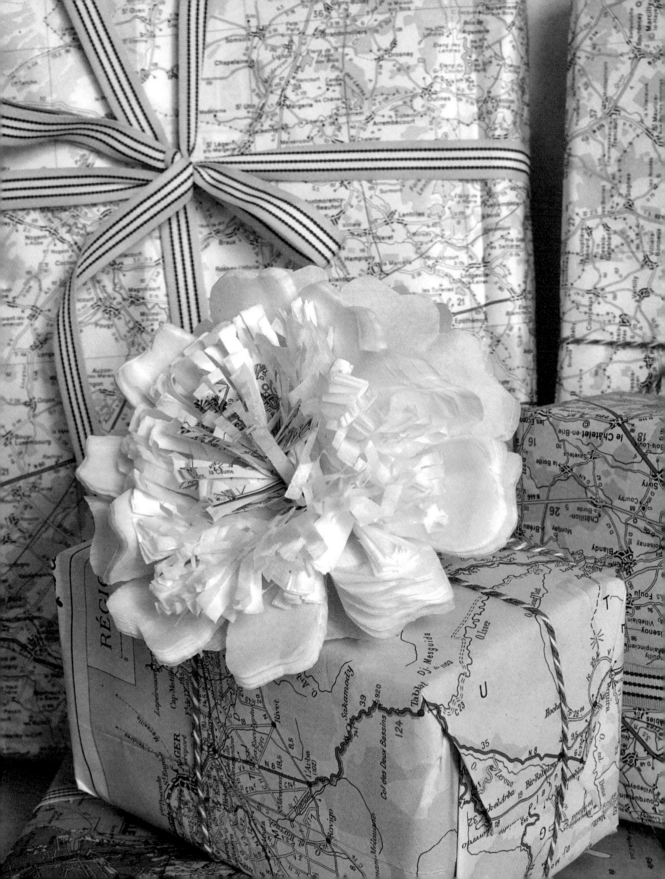

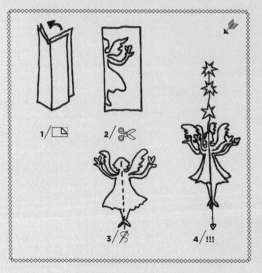

1/ □ 2/ ✂ 3/ ✎ 4/ !!!

CHRISTMAS ANGELS

Pop-up angels to bring you peace and joy.

Trace half the template on the right. Fold pieces of paper in half and cut out half the angel shape, then open out. Lay two cut-out angels on top of each other and sew them together down the middle. if you like, you can cut out a couple of stars, too, and sew them onto the top. Then open out the layers of paper to make your angel 3D.

Once you have cut out a few angels, try cutting some without a template – you might find you prefer creating them freehand as it's less restrictive.

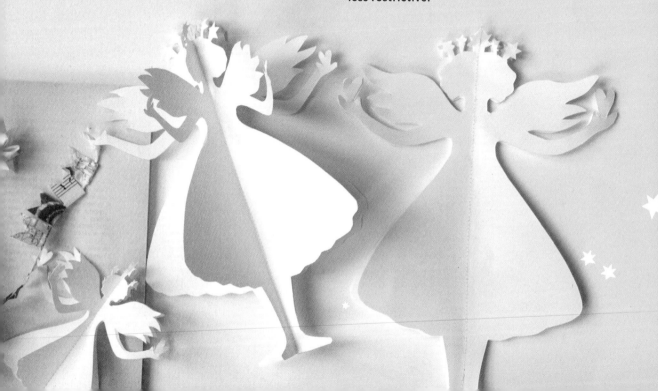

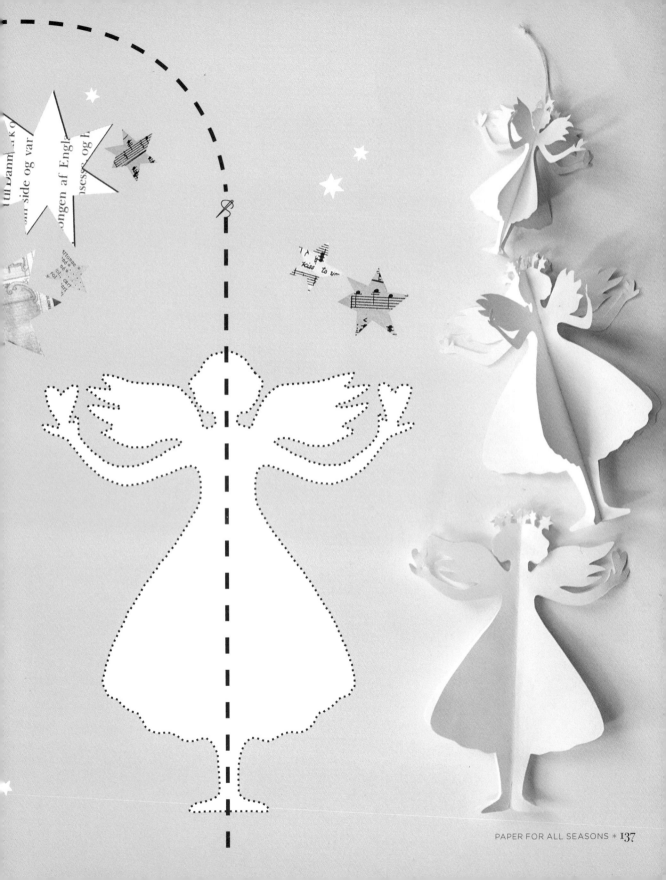

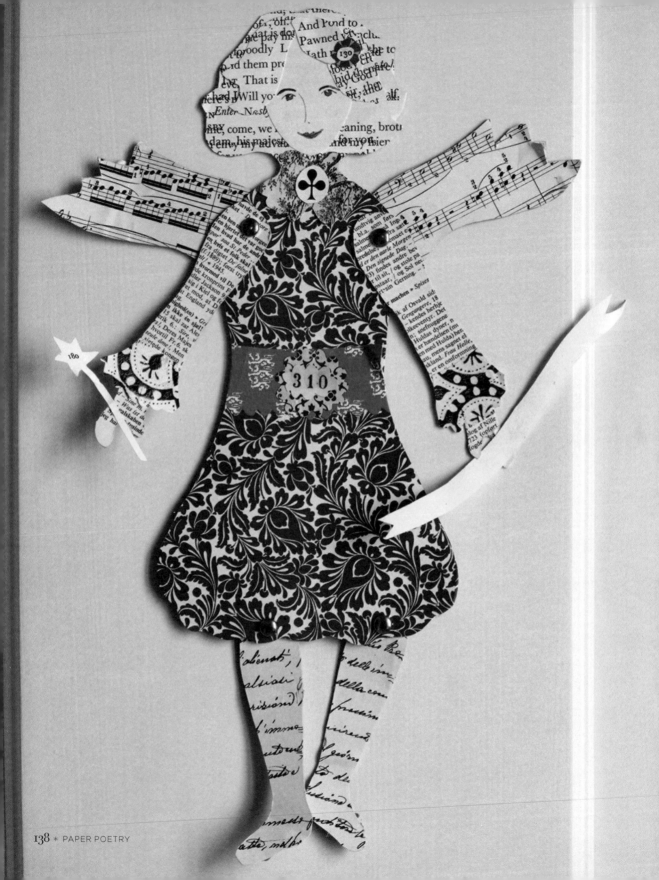

FOLDING ANGELS

These folded angels are simpler than they look. Experience the joy of accurately folding every single page of an old book and transforming it into a new volume. Create your own rhythm, and take your time – giving it your full attention is satisfying in itself.

✎ **Take an old book, and fold as follows:**

Fold each page from the right-hand corner down towards the spine – do this for every page in the book.

Now fold every page once more, this time the other way, creating a narrower triangle. There will be a bit of 'leftover' paper at the bottom of each page. Fold this up around the pleated page.

When you're finished with the folded cone shape, you can choose whether or not to remove the cover of the book (see right) and cut out and attach a head and a pair of wings.

[For a video of this project, visit our YouTube page, Paper Poetry, and watch 'Helene and Simone's Angel Making'.]

↘ *Add glitter to the edges of the pages for extra dazzle.*

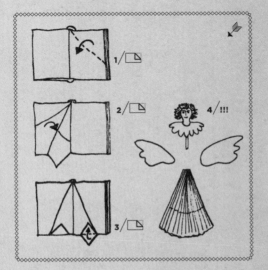

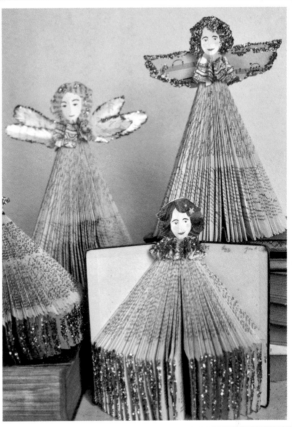

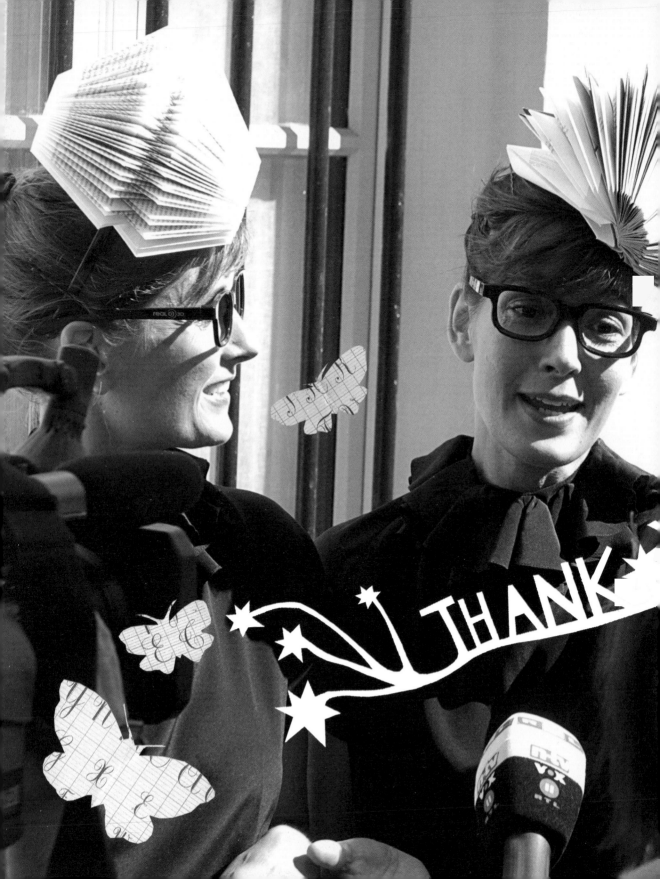

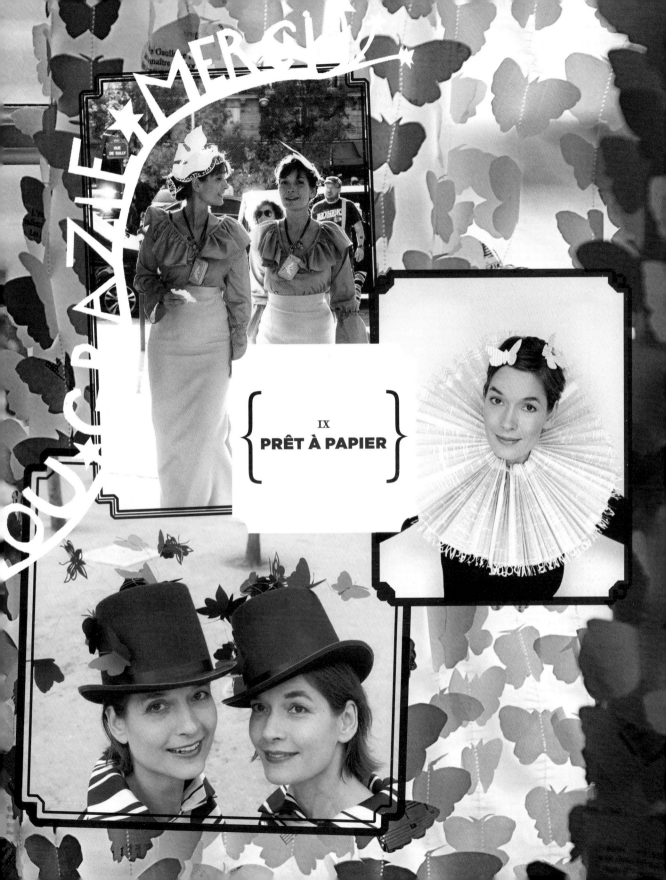

IX
PRÊT À PAPIER

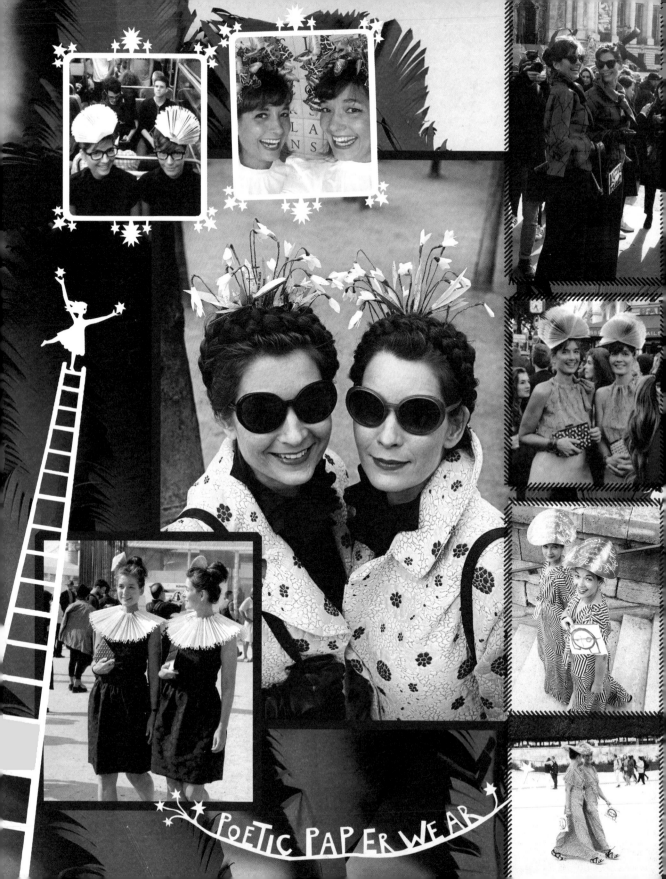

POETIC PAPER WEAR

- - -
WEARABLE
PAPER
- - -

In order to promote our design brand, Edition Poshette, we love to attend Paris Fashion Week and sprinkle it with our paper poetry.

Our handmade and hand-printed leather goods are intended for courageous women who want to add an element of poetic luxury to their everyday life.

In some ways we feel fashion has lost that touch of poetry and fun – it is often too costly, takes itself too seriously and can lack a message.

So we amuse ourselves by creating headpieces out of paper, costing us nothing but our time, yet investing in our creativity by wearing and sharing these in fashionable Paris.

Sometimes all it takes to be 'fashionably elegant' is being 'clever' about how you wear what you wear.

SIMPLY ADD A TOUCH OF PAPER POETRY AND THE WORLD SMILES BACK AT YOU.

GIOIA Amour amore ENJOY JOY

FILL YOUR PAPER WITH THE BREATHINGS OF YOUR HEART.

BETTY MATTEO DAVID LILLY KRISTINA BUGSI TARA
CHRISTOPHER ANNABELLE ERNESTO PIA ISABELLE
MIKKEL CLAUDIA CLARA THEA BEN LUCY IAKOB KASPER
PABLO POLLY ELIAS OSCAR MIGALA THOMAS
VORES MOR OG-FAR

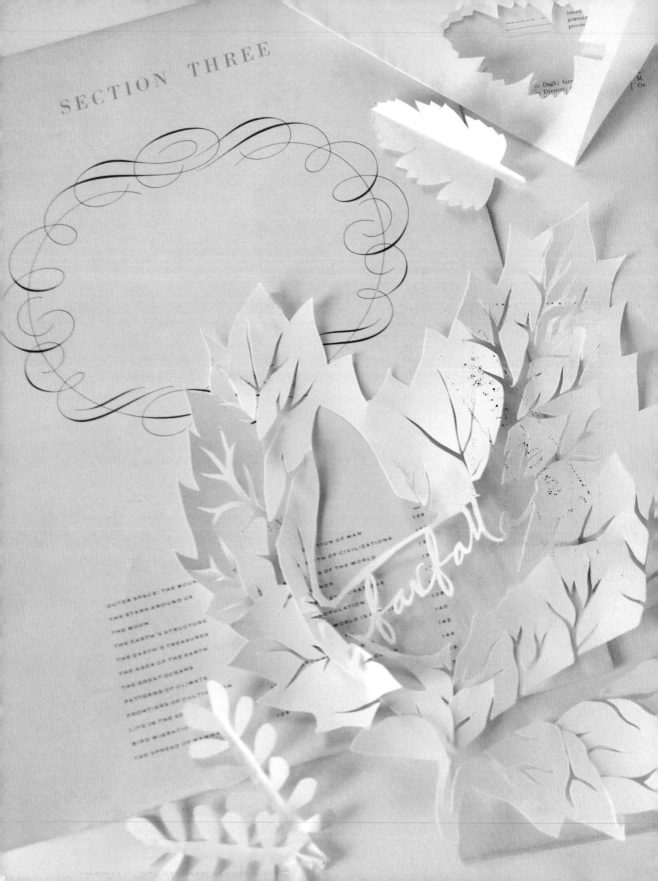